FDNY

AN ILLUSTRATED HISTORY

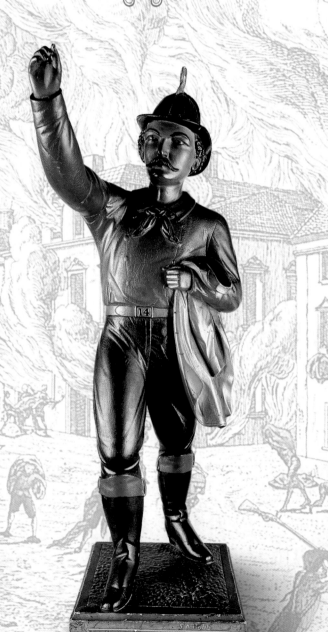

COLUMBIA

F.D.N.Y. An Illustrated History of the Fire Department of the City of New York,
As Seen Through The Collection Of The New York City Fire Museum

Text © 2003 by NYC Fire Museum, edited and with substantial additional text by Andrew Coe
All museum artifacts © 2003 by F.D.N.Y.

Library of Congress Catalog Card Number has been requested.
Hardback ISBN: 962-217-659-3
Paperback ISBN: 962-217-714-X

Series conceived by Magnus Bartlett & Richard Hayman
Designed by Alex Ng Kin Man
1999/2002 Museum photography © NYC Fire Museum/Airphoto International Ltd.
Museum photography by David Dean Leith, Gerardo Somoza, and Magnus Bartlett
1970s photo essay © Steven Scher, from *Fire!*, H. N. Abrams, 1978 (p.83 bottom, p.87, pp.90–92, pp.94–95, p.96 top, pp.97–103)
1980s photo essay © Matthew P. Daly (p.107, pp.110–111, pp.114–116, p.135)
2001/2002 photo essay © FDNY Photo Unit (pp.117–132, p.136)
Paul Thayer (p.72, p.77 bottom, p.80 top left, pp.84–85)
Gary Urbanowicz (p.54 bottom left, p.66 bottom)

Printed in Hong Kong by Twin Age Limited, Hong Kong
E-mail: twinage@netvigator.com

An Odyssey *American Icon,* production by Airphoto International Ltd.
E-mail: odysseyb@netvigator.com
www.odysseypublications.com
In association with the James Brown House, a Landmark of the City of New York, at 326 Spring Street, New York, NY 10013

JAMES
BROWN
HOUSE
Est. 1817

Distributed in the United States by
W.W. Norton & Company, Inc.
500 Fifth Avenue
New York, NY 10110
Tel: (800) 233-4830 Fax: (800) 458-6515
www.wwnorton.com

ACKNOWLEDGMENTS
We would particularly like to thank the following people for their extremely generous help during the preparation of this book:
Battalion Chief George Eysser (Ret.), Joann Kay (Director of the NYC Fire Museum), Peter Rothenberg (curator, NYC Fire Museum), Daniel Maye (Chief Librarian F.D.N.Y), Steven Scher, Peter Micheels, EMS Chief J.P. Martin, Harvey Eisner, Jack Lerch, Matthew P. Daly, Firefighter Eileen Gregan, Anne Lawrence, the FDNY Fire Zone and especially Lieutenant John Leavy of the FDNY Photo Unit together with Ralph Bernard and Kimberlee Hewitt. To those we may have inadvertently overlooked our sincere appologies.

Title page: *Hand-carved sculpture of a firefighter (c. 1878) that decorated the firehouse of Columbia Engine Co. 14.*

CONTENTS

BIRTH OF A FIRE SERVICE

The first European settlement of what is now New York City was caused by fire. In 1613, a Dutch merchant ship sent to trade fur with the Indians caught fire on the waters off Manhattan Island. Captain Adriaen Block was forced to abandon ship with his crew, leaving the vessel to be consumed by flames. They landed on Manhattan and spent the winter there in rude huts at the island's southern tip-where the towers of New York's Financial District would later stand. When the snow melted, Block enlisted the help of local Indians in building a boat to take them back to Holland.

Warning rattles carried by New Amsterdam's Rattle Watch.

New York City would experience many more disastrous fires in its history. Over the years, as the population and the buildings grew, the city would confront the threat of fire with technological advances and organizational changes in firefighting. These changes rarely came easily, however. They met resistance both from firefighters who favored outmoded but reliable methods of extinguishing fires and from politicians and business owners not willing to bear the added cost. But change usually won out in the end, because fires kept on happening, and New Yorkers realized they had to either move forward or risk even greater disasters.

In 1625, the Dutch West India Company established its first permanent settlement on Manhattan Island and called it New Amsterdam. The town grew haphazardly, with few laws to regulate its citizens' lives. Drunks were a common sight, and visitors complained about the pigs and other animals running freely through the streets and rooting through the many piles of garbage. In 1647, a new governor, Peter Stuyvesant, arrived from Holland and saw that the inhabitants had "grown very wild and loose in their morals." He immediately set about imposing order on the settlement, cleaning the streets, closing taverns, and in 1648 drafting the first fire regulations.

Most New Amsterdam chimneys were made of wood, and most roofs were thatched; these hazards created the possibility of

Early fire buckets were often painted with the owner's name and address.

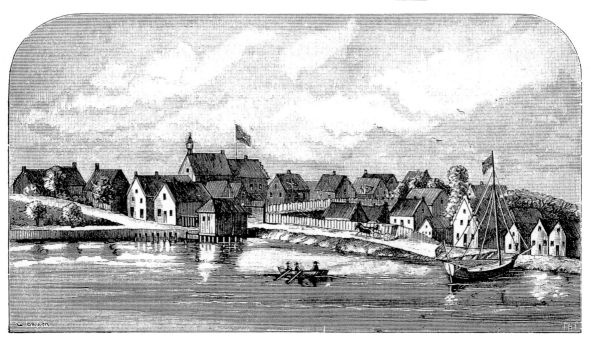

a conflagration in the closely-built town. Stuyvesant banned the further construction of wooden chimneys and required homeowners to regularly sweep their chimneys and put out all fires after curfew. Actual building fires, no matter how they began, resulted in large fines. Fire wardens were appointed to inspect the chimneys; the money collected from fines went towards the buckets, hooks, and ladders that were the fire fighting equipment of the day. In 1658, citizens were ordered to pay a tax in coin or beaver skins to pay for 250 leather buckets made by two local shoemakers. The buckets were stored in the city hall and the principal houses of the city.

*T*hat same year, the city established its first fire company. Called the "prowlers" or the "rattle-watch," the company started with eight men and soon swelled to 50. They would take turns patrolling the streets from sunset to dawn watching for any signs of fire. Upon spotting a blaze, they would create a loud racket by swinging their rattles and then run for the buckets. Though prowlers were the first line of defense against fire, every able-bodied person was expected to come out and help extinguish the flames. Where possible, long lines of people were formed to pass buckets

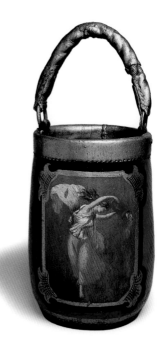

Ornately hand-painted fire bucket.

of water to the fire and pass the empty ones back for refilling at wells or the river.

In 1664, the Dutch surrendered New Amsterdam to a superior English force. As the masters of the town they renamed New York, the new British rulers changed few of the colony's rules (except the official language). The fire ordinances of this period pertained mostly to buckets, ladders, hooks, and

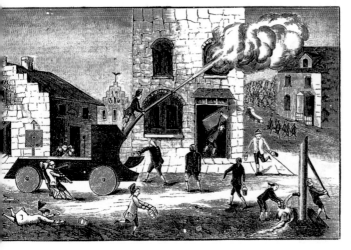

New York City fire scene circa 1730.

chimney fines. In 1686, for example, the government ordered that: "by reason of great damage done by fire ... every person having two chimneys to his house provide one bucket ... every house having more than two hearths provide two buckets." In order to ensure the proper return of buckets after a fire, a 1692 law mandated that following a fire, all the buckets were to be collected and brought to City Hall, where they would be retrieved by their owners. Buckets remained the sole means of conveying water to a fire until 1731.

THE FIRST FIRE ENGINES

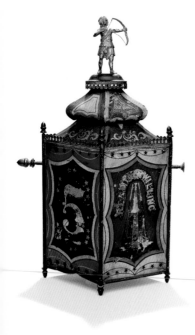

Ornate signal lamp (c. 1790) that was carried atop a pole to warn people that the fire engine was on its way.

Though simple wooden fire engines had existed for some time in Europe, they were expensive and cumbersome machines. In 1731, New York City ordered its first two engines from Richard Newsham, a London manufacturer. These were composed of an oblong wooden box with a condenser case in the center and short arms at either end that worked a pump in a seesaw fashion. When the alarm was called, firefighters had to pull the heavy engine to the fire themselves, lifting it around corners because the wheels did not turn (horses did not become common for pulling fire engines until the 1860s). Then they would use buckets to fill the case-workable hoses did not exist-and begin pumping the handles. The water would squirt out of a long metal nozzle that projected from the top of the pump; in later models, the nozzle

could be rotated to aim at the fire. These engines were an improvement over the simple bucket brigades, but not much. They were housed in two shacks near City Hall and creatively named Engine 1 and Engine 2. Men were hired to maintain the engines but it was the city Aldermen who took charge of them at fires.

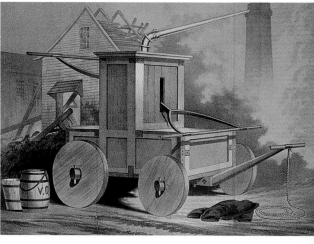

Early fire engine (c. 1743) built for New York's Engine Co. 3.

*I*n 1737, the need for a more organized firefighting force was recognized and the Volunteer Department of the City of New York was established. The act creating the department called for: "the appointment of able, discreet, and sober men who shall be known as Firemen of the City of New York, to be ready for service by night and by day and be diligent, industrious and vigilant." The department started with 35 members, all respected men from a variety of trades, and more men and fire engines were added as the city expanded.

Few of these firemen were in town, however, on September 21, 1776. Just a few days before, British troops had driven George Washington's Continental Army from the city, and most of its inhabitants had fled in their wake. A fire started in a tavern and, pushed by a strong wind, rapidly spread up the west side of the city, burning over 500 houses and other structures along its path. A quarter of New York was destroyed, and it would be almost 10 years, until well after the British withdrawal in 1783, before the city was completely rebuilt. The British declared that the fire was sabotage and rounded up hundreds of suspect (including Nathan Hale, who was hanged as a spy) but never were able to convincingly prove their charges.

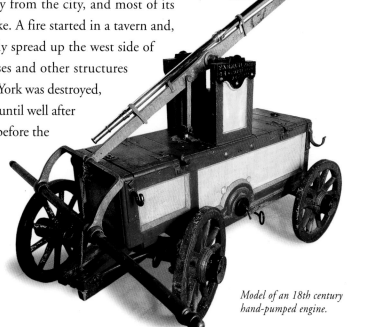

Model of an 18th century hand-pumped engine.

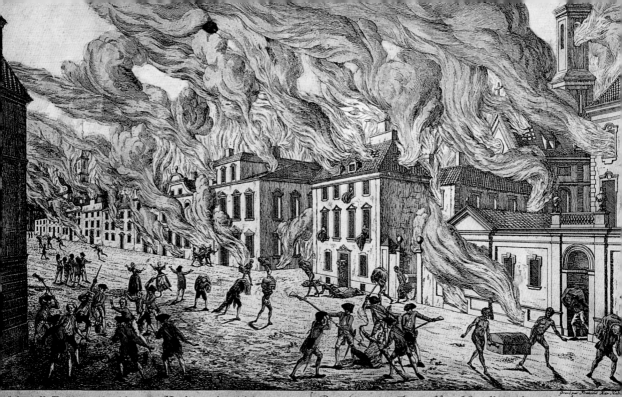

rückenvolle Feuersbrunst welche zu New Yorck von denen Americanern in Nacht vom 19. Herbst Monath 1776. angeleget worden, wodurch alle ...de auf der West Seite der neuer Börse längst der Broock-trent biss an König Kollegii mehr als 1600 Häuser, die Dreyfaltigkeits Kirche, die ...herische Kappelle u. die Armen Schule in Asche verwandelt worden.

Representation du Feu terrible a Nouvelle Yorck. que les Americains o... ...ume pendent la Nuit du 19 Septembre 1776. par le quel ont ete brulés. t... les Batiments du Cote de l'est. a droite de Börse dans la Rue Broock jusqu'au Collège du Roi et plus que 1600. Maisons avec l'Eg... de la S.te Trinite la Chapelle Lutheriene et l'Ecole des pauvres

The first "great fire" in New York occurred in September of 1776, shortly after the British captured the city. A fire began in a tavern down by the docks and, driven by the wind, soon swept northward. By dawn, fully a quarter of the city's buildings had been consumed.

Speaking trumpet carried by fire company foreman Peter Roome to relay orders to his men.

*A*fter Independence, New York's fire department expanded to 15 engine and two ladder companies. In 1798, it was reorganized and incorporated as the Fire Department of the City of New York. As the city expanded, however, inducements were needed to keep a sufficient number of volunteers. In 1816, for example, the legislature granted firefighters who had served for 10 years permanent exemption from jury and military duty. The fire department also needed money for new equipment and to improve firefighters' working conditions. As a corporation, the fire department was authorized to raise money on its own behalf and "for the relief of ... indigent or disabled firemen or their families." Money continued to be collected from chimney fires, certificates, and donations, and the annual Fire Department Ball, initiated in 1828, also became a major source of funds. In the town of Brooklyn across the East River, the development of fire fighting followed a similar, albeit

slower, trajectory. A volunteer fire fighting force of five men and one captain formed in 1785 when Brooklynites purchased their first engine. Manufactured in New York City, this boxy and cumbersome engine was capable of throwing a stream of water 60 feet in the air; it was patriotically named the Washington No. 1.

COMPANY CULTURE

*T*he houses where the fire engines were kept quickly became meeting and socializing places for firefighters. They spent many hours at their company stations, not only to be ready to answer an alarm but to enjoy the company of their fellow firefighters. The volunteers' traditional uniform was a leather helmet and a colored flannel shirt (this later changed to a red wool shirt). Speaking trumpets were symbols of authority for fire chiefs who used them to bark out orders. Firehouse rules could be strict, though the regulations served more as a means to raise funds than to control behavior. Fines were levied for missing meetings, for being late to a fire and, particularly before the 1840s, for chewing tobacco, drinking, and swearing. In the early 19th century, it was against regulations for firemen to bunk with their engines-though they did-since it was feared that the arrangement would lead to activities such as drinking and gambling. It was not until 1857 that Harry Howard, as his first act as Chief Engineer (the highest ranking officer in the Volunteer Department), established sleeping quarters in fire houses as the official norm. As soon as firefighters began bunking together, the pranks began—a tradition that continues today as an essential rite of passage for every new firefighter.

*P*ride in one's fire company became a very important aspect of the culture of the volunteer firemen. Initially the only impetus for running to a fire was to extinguish it as fast as possible. As more and more fire companies formed, however, the race took on a life of its own, and the reputation of a company was made and tarnished in these very public displays of speed and endurance. Indeed, the race to a fire and the fire itself was for many a spectator sport. Long after the days when all the citizens of the city were

Signal lamp carried by a fire company runner.

Patriotic themes were common in the decorations on engines. This circa 1830 condenser cover from Brooklyn's Engine Co. 1 bears the likeness of George Washington.

Model of an early 19th century "gooseneck" or "New York" style engine with an artfully-painted condenser cover.

Gold-leaf-decorated wheel on a 19th century engine.

Right page: *1807 certificate appointing Thomas Burtis a New York City fireman.*

expected to help put out a fire, large crowds would form to watch the blaze and the firemen's efforts to extinguish it. Complaints that bystanders were interfering with the operations of firefighters, and vice versa, were not uncommon.

One important early 19th century advance in firefighting technology was the introduction of hoses, leading to the eventual demise of the fire bucket. The first hoses were stitched along their entire length and thus very leaky. In 1808, riveted leather hose was introduced and proved to be a great improvement. By 1819, the use of buckets at fires officially ended, as the city adapted older engines to use hose and bought new, specially designed hose carts as well. Separate hose companies were formed and joined in the race to fires.

Water availability also improved at the beginning of the 19th century. The Manhattan Water Company was authorized to establish a water system in 1799 and soon began installing wooden water mains. The first fire plug of any kind, with a direct

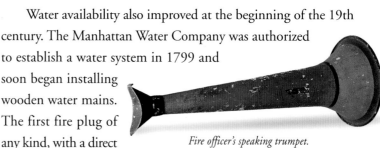

Fire officer's speaking trumpet.

connection to the water main below the street, was introduced in 1807. The first fire hydrant in New York with an opening and closing valve, a crude version of a modern hydrant, was introduced in 1817. Hydrant companies were established in 1831 to operate and maintain the hydrants; until these companies were disbanded in 1855, they too could be seen dashing to fires.

Though watchmen patrolling the streets were still the principle means of reporting fires, in 1830 a central fire bell was placed in the cupola of City Hall. Here lookouts were on 24-hour guard and would ring the alarm bell if they saw a fire. A torch was hung from the tower at night, and a flag by day, pointing in the direction of the fire. Upon this alarm, bells would peal throughout the city, continuing until the blaze was extinguished.

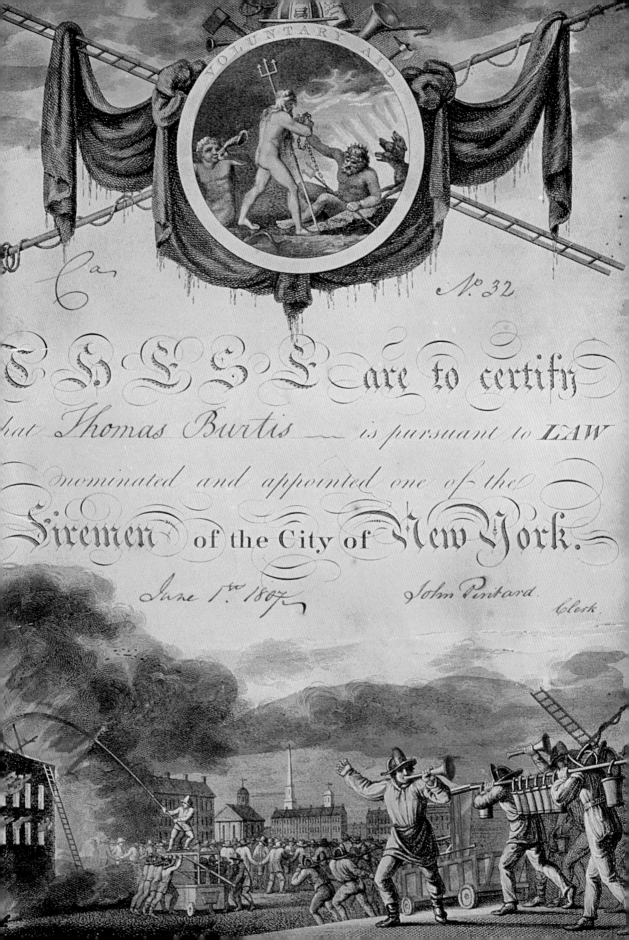

VOLUNTARY AID

N.º 32

THESE are to certify that Thomas Burtis — is pursuant to LAW nominated and appointed one of the Firemen of the City of New York.

June 1.ᵗᵒ 1807

John Pintard.

Clerk.

The Croton Aqueduct

For the first two centuries of city history, the greatest problem faced by firefighters was finding adequate supplies of water. After 1800, the old haphazard system of using wells and ponds (and the Hudson and East Rivers if nearby) was gradually supplanted by the Manhattan Company's network of wooden pipes connected to a small reservoir at Chambers Street. Firefighters could tap into these pipes, actually hollowed-out logs, but the flow was irregular and occasionally non-existent due to clogs and leaks. In 1829, the city built a second reservoir at Bowery and 13th Streets and constructed 40 cisterns around Lower Manhattan, all specifically for firefighters' use. Nevertheless, New York was still plagued by fires, as well as epidemics of cholera caused by poor sanitation and unclean water.

Typical mid-19th century double-decker hand-pumper.

In 1835, just a few months before the Great Fire, the city embarked on one of its greatest public works projects ever: to bring limitless supplies of clean water to Manhattan. The construction of the Croton Aqueduct took seven years. Engineers dammed the Croton River in Westchester County and constructed a 41-mile-long aqueduct ending at a large reservoir in present-day Central Park. From here, the water was sent to a distributing reservoir at Fifth Avenue and 42nd Street (the site of Bryant Park and the public library's Main Branch) and then onward to a third reservoir at 13th Street.

When the Croton Aqueduct opened in 1842, the city celebrated with one of the largest parades ever seen, culminating at City Hall where the fountain shot Croton water 50 feet into the air. New Yorkers, who had preferred their drinks alcoholic, went water-mad, and bars had to offer "glasses of Croton" as well as beer and whiskey. George P. Morris penned the official "Ode to Croton," with the following lines:

> *Water leaps as if delighted,*
> *While her conquered foes retire!*
> *Pale Contagion flies affrighted With*
> *the baffled demon Fire!*

A section cut from a water pipe of the early 1800s: the first water mains in New York were constructed from logs with holes bored down the center.

A few months later, Croton water helped extinguish a fire on Gold Street, and insurance companies estimated that the damage would have been a million dollars greater without the new supply of water.

In 1847, the city was divided into three fire districts, and then to eight districts three years later. Each district had a watch tower and alarm bell, and the number of strokes of the bells indicated in which district a fire was burning. Communication between towers was vastly, though initially unreliably, improved in 1851 when telegraph wires were run between the towers. In 1853, this alarm system was connected to 68 firehouses in lower Manhattan and to a central office in the basement of City Hall. Each firehouse could then both receive alarms and alert the central office of fires.

"Hand In Hand": early 19th century Philadelphia fire company's parade hat.

*I*n 1840, Engine Company No. 38 was the first in New York to use a double-decker, or "Philadelphia" style, engine. Named the "Southwark" after the area of Philadelphia where it was built, the engine was larger and more powerful than its predecessors. It utilized the pumping action of firemen more efficiently, providing a stronger stream of water. Upwards of 40 men standing on two levels, on the ground and on the engine

"Ruins of the Merchants Exchange New York after the Destructive Conflagration of Dec. 16 & 17, 1835," by N. Currier.

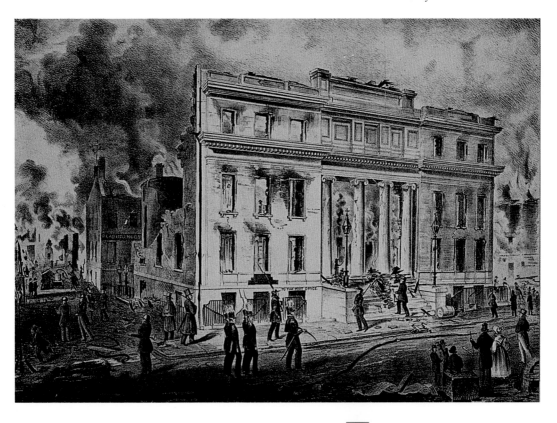

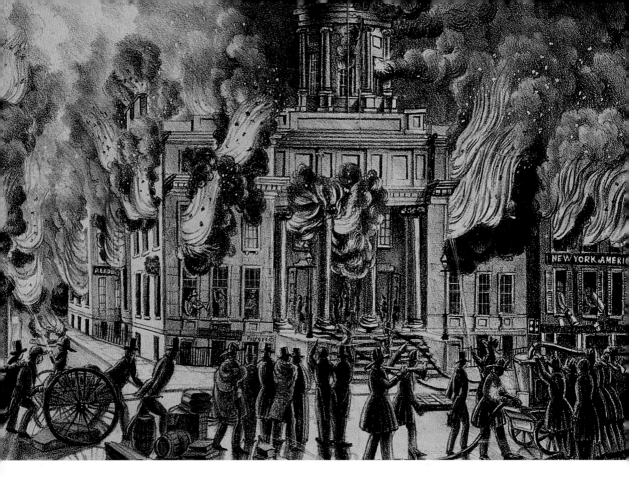

Burning of the Merchant's Exchange during the 1835 Great Fire.

itself, were needed to operate it. Engine 38 introduced it to the city as a private purchase and later sold it to the department. Though many firefighters were initially opposed to double-decker engines, they were widely accepted after they proved their worth at fires.

It was unusual for companies to buy their own apparatus, but it was standard for them pay for their decoration out of their own funds. Companies frequently took their engines out for review at July 4th parades and other occasions; large amounts of money and energy were expended to make engines stand out. Artists were hired to paint scenes on side panels; ornate lanterns and hardware were added; and Engine Company 13 went so far as to silver-plate all the metal work on its engine.

This 19th century parade axe was mostly for ornamental use.

FIRES AND POLITICS

*O*n the 1830s, the nature of the competition between companies grew increasingly less gentlemanly, as did the composition of the fire department itself. Mention of fights between engine companies is first recorded in the 1830s; two decades later, inter-company violence had become commonplace, with knives and revolvers replacing fisticuffs. Although fights broke out for a myriad of reasons, access to water was one major source of tension. Engine companies raced not only to put out the blaze but also to be the first to get to the nearest, and possibly only, hydrant or cistern. Hose companies, and occasionally street gangs, created difficulties by blocking all but their favorite engine company from the hydrant. Those firefighters that arrived too late could only stand by and watch as the others became heroes of the moment. This competition was further exacerbated by the close proximity of firehouses, and nearby houses typically developed fierce rivalries. Often it was not firefighters themselves that started a brawl but the "runners" who accompanied the engines. These were boys who were too young to officially join a company but who would run with the engine, helping to pull it or to clear the streets ahead. This anonymous 1854 poem, "The Runner's Lament," evoked the excitement of the runner's life:

Fireman Mose, the iconic firefighter of the mid-19th century, blocks a rival company's hose line.

I was a jolly runner bold,
When runners were all hunk;
I ran to fires, I fought, I swore,
And occupied a bunk.
Owl-like, I slept most all the day
And kept awake at night,
With joy I heard the clanging bells
And saw the rising light.
My blood went tingling through my veins,

My heart throbbed with desire,
When'er I heard the welcome cry,
"Turn out, boys! Fire! Fire! Fire!"
Quick—man the ropes—the rushing tramp,
The rattling wheels—the crowd—
The hose-cart wheels—the trumpet shout—
The Hall bell, deep and loud!

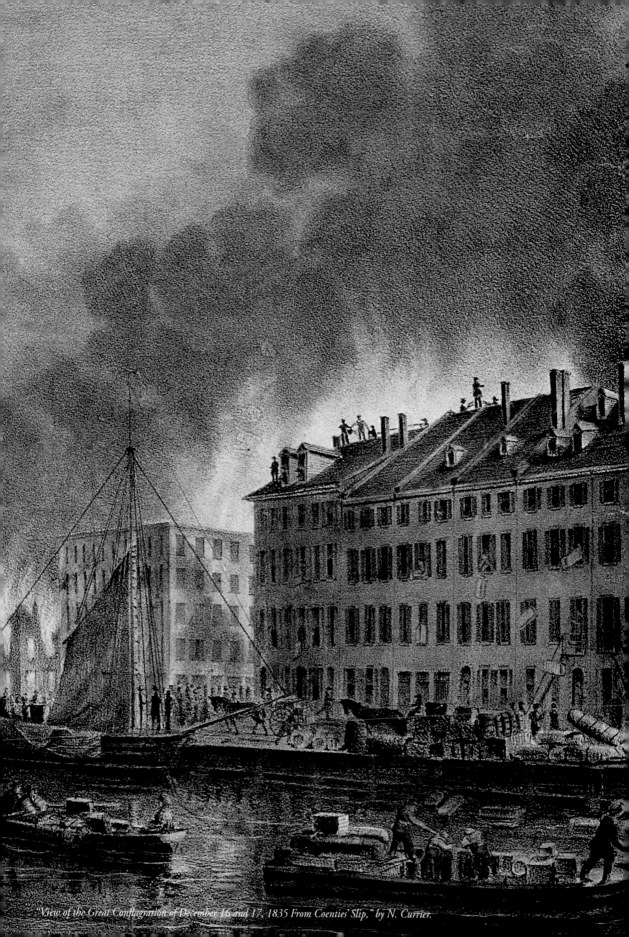

"View of the Great Conflagration of December 16 and 17, 1835 From Coenties' Slip," by N. Currier.

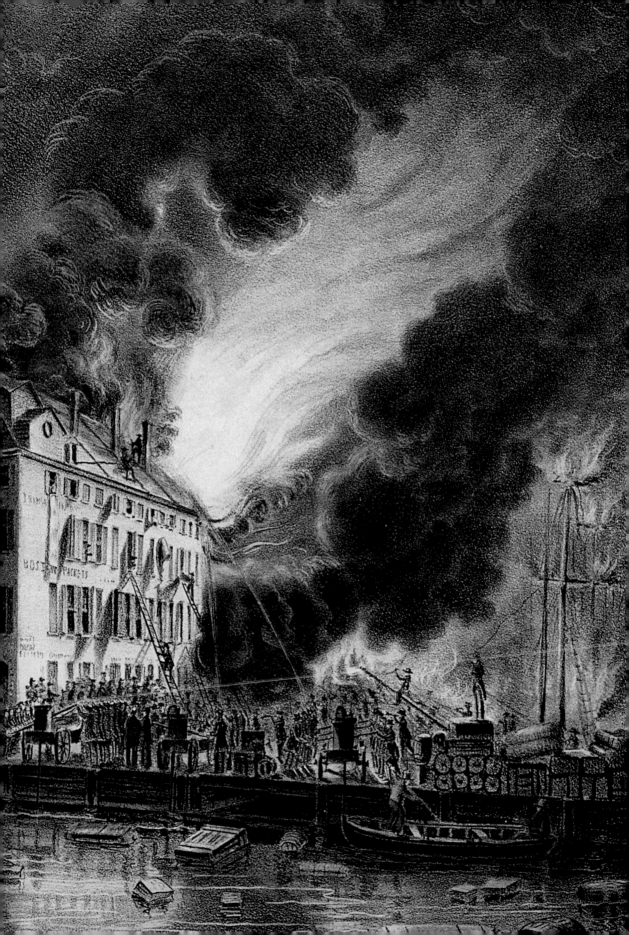

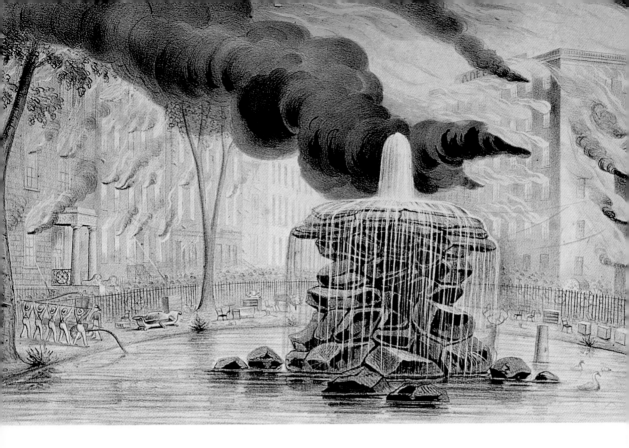

Commemorative plate depicting the Great Fire of 1835 from the East River.

On a frigid and windy night in December of 1835, New York City suffered one of its most disastrous fires. It began in a warehouse downtown and, blown by the wind, quickly spread, destroying 674 buildings, mostly businesses and warehouses, including the New York Stock Exchange and Delmonico's restaurant. Firefighters, already exhausted from several smaller fires the night before, were severely hampered by the bitter cold which froze hydrants, engines, and hoses. Many tried to salvage the mountains of goods held in threatened warehouses, but even supposedly safe locations were consumed by the blaze. The fire was finally stopped by blowing up the buildings in its path so it could not spread further. After it was extinguished, New Yorkers discovered that 13 acres of their city had been destroyed, dealing a devastating blow to the economy and throwing thousands out of work. A young newspaperman named James Gordon Bennett toured the scene and wrote the following description for his readers:

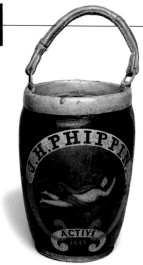

proceeded to the corner of Wall and Front Streets. Here I saw a horrible scene of desolation. Looking down South Street toward the south nothing could be seen but awful ruins. From the corner of Wall Street I proceeded southwardly, for I cannot now talk of streets; all their sites are buried in ruins and smoking bricks. No vessels lay here at the wharves, all were gone. I went down the wharf; the basin was floating with calicoes, silks, teas, packing cases, and other valuable merchandise. Piles of coarse linen and sacking encumbered the street. Going a little farther south, on what was formerly Front Street, I encountered a cloud of smoke that burst from a smoking pile of stores. Emerging from this sirocco, I found myself near a group of boys and ragged men. A fire was hissing away, made out of tea boxes and Hyson tea itself. Several dirty little girls were gathering up the tea and putting it away in baskets. Proceeding farther, I encountered hogsheads of raw sugar, half-emptied, and their contents strewed, like the Hyson tea, over the pavements and bricks. Boys and girls were eating it as fast as they could.

19th century fire bucket.

The Great Fire of 1845: a huge explosion destroys 38 Broad Street, sparking a fire that burned 200 buildings.

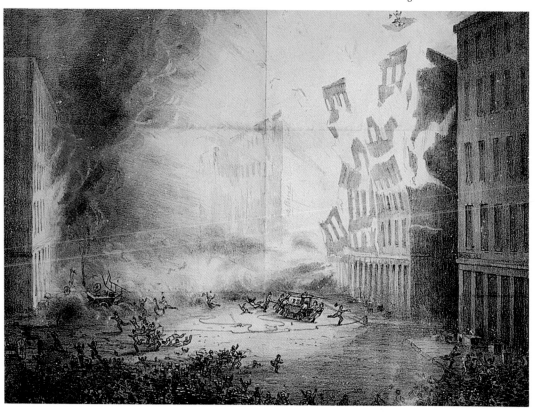

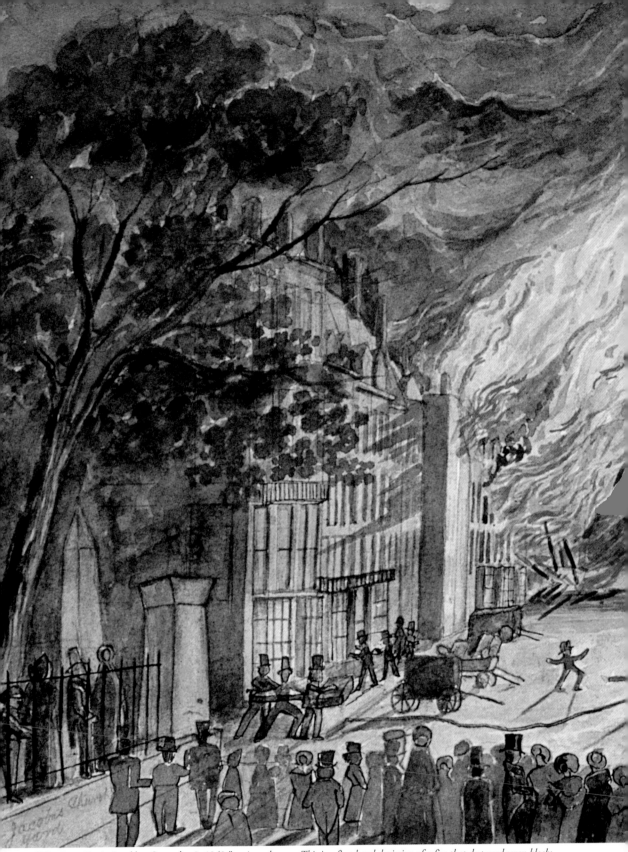

"The Great Fire in Brooklyn, September 9, 1848," artist unknown. This is a first-hand depiction of a fire that destroyed seven blocks of buildings including three churches, two newspapers, and a post office in Brooklyn Heights.

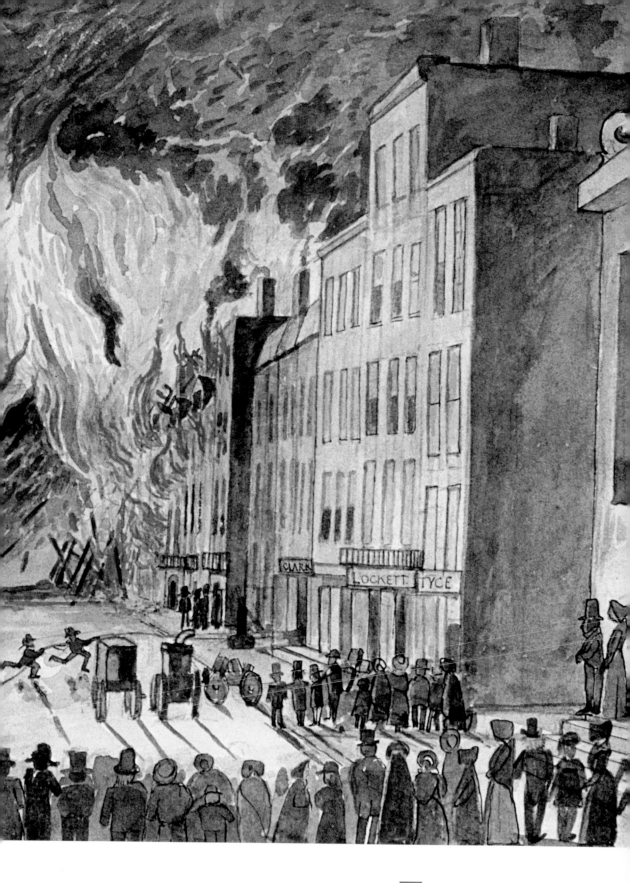

*Early 19th century Chief
Engineer's helmet frontpiece.*

The fire also inflamed tensions over political control of the fire department. Many blamed the Chief Engineer of the Volunteer Fire Department, James Gulick, for the extent of the destruction. While he was overseeing the efforts at a later blaze, the City Council dismissed him. Immediately, a number of firefighters stopped fighting the fire, and a worse disaster was averted only when the dismissal was rescinded. This stay was short-lived, however, as Gulick was fired again, and over a third of the department resigned in protest. They returned about a year later, after they elected enough supporters to the City Council to select a new Chief Engineer of their own choosing.

Volunteer companies played an important role in city politics until they were disbanded in 1865. Joining a fire company was for some a calculated first step into politics. Seven New York City mayors started their careers as volunteer firemen, as well as one of the most notorious figures in New York City political history, William M. Tweed. A cabinet maker by trade, Tweed established the Americus Engine Company Number Six in 1848 and went on to become the Grand Sachem of Tammany Hall, the most powerful political machine in the city's history. New York politics were particularly rough-and-tumble during the 1850s, and firemen often waded in to the fistfights and pitched battles supporting or attacking various candidates. Indeed, many believed they spent more time street fighting than putting out fires. When Chief Engineer Alfred Carson bitterly criticized city council for reinstating the fire companies he had suspended for fighting (including Tweed's), the councilmen responded by backing Harry Howard in the next department election. Luckily, the popular Howard proved to be one of the most dynamic leaders of the volunteer department.

7th Ward Fire Warden's frontpiece.

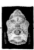

In 1854, the insurance industry, one of the loudest critics of the volunteer department, established the Fire Patrol, a paid salvage company which attempted to rescue goods and furniture from burning buildings. Insurance companies also backed the use of steam-powered fire engines, the first of which was put into service in 1859. Like the double-decker engine, steam engines were initially seen as too powerful and cumbersome; for many firefighters, the greatest displeasure stemmed from the fact that they required far fewer men.

In 1858, many of these new pieces of apparatus were put on display at the Crystal Palace exposition hall at the site of today's Bryant Park. This enormous glass and iron building was advertised as fireproof; unfortunately its contents were not. As reported in the New York Times, here is what occurred:

Engine company badge, circa 1860-65.

*A*t ten minutes after 5 o'clock yesterday afternoon, the famous Crystal Palace, where the Fair of the American Institute was being held, took fire. The flames spread so rapidly that in twelve minutes the dome fell, and in twenty-one minutes almost the whole structure was burned to the ground. One of the minarets still stands, and small portions of the wall are yet erect. The firemen were on the ground in fifteen minutes after the first alarm, and worked manfully, but they were too late to be of service. They kept playing on the ruins all the evening, hoping to save some of the machinery....Many of the visitors inside leapt from the windows, and climbed down the pillars of the plazza [sic], and for a long time it was thought that some must have perished in the flames, but at midnight we could not learn that any lives had been lost.

Friendship Hook and Ladder 12 frontpiece belonging to A.J. Garvey.

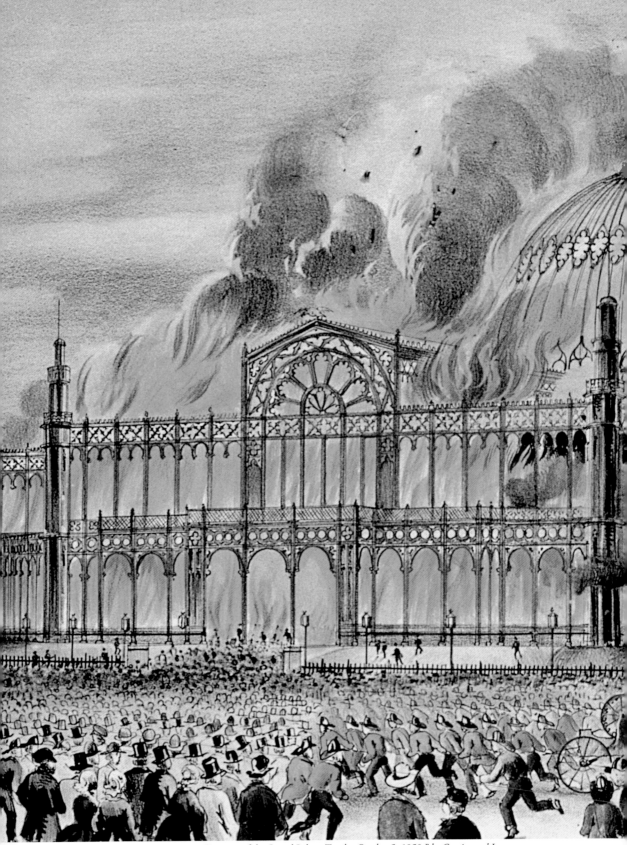

"Burning of the Crystal Palace, Tuesday October 5, 1858," by Currier and Ives.

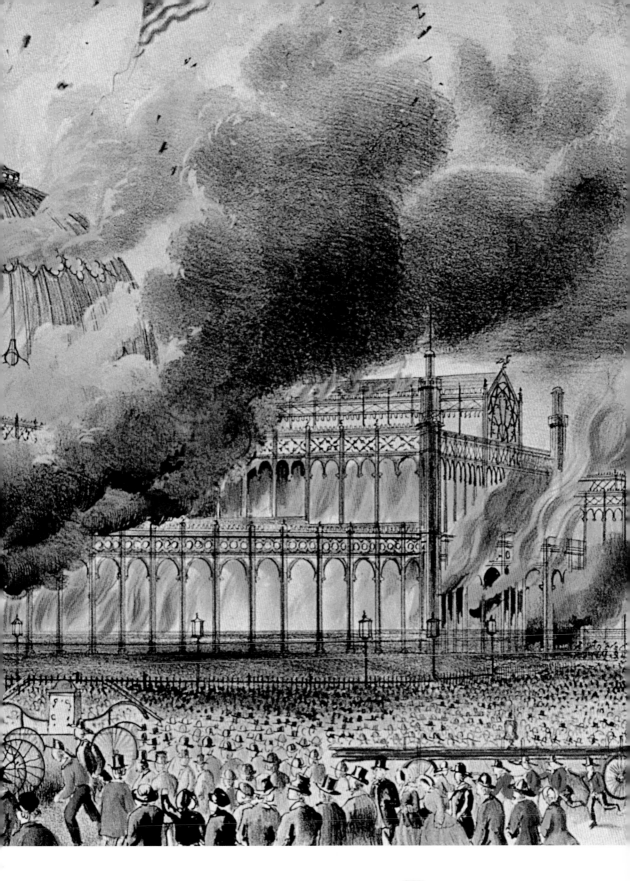

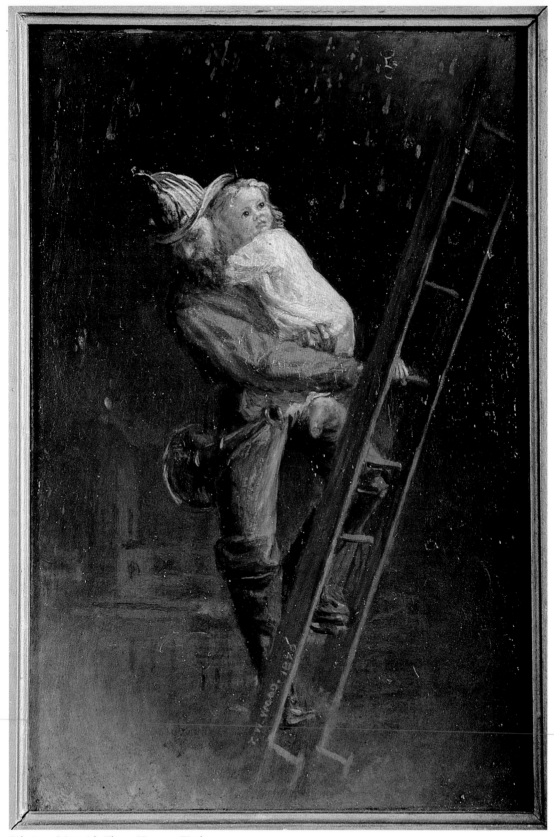

"The Rescue" (1870) by Thomas Waterman Wood.

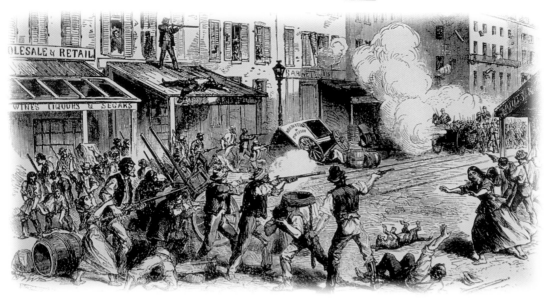

On July 13, 1863, volunteer firemen helped spark one of the most devastating weeks in New York City history. Angered that they had lost their exemption from the Civil War draft, they joined a huge demonstration of city workers and poor people against forced conscription. When the members of Black Joke Engine Company 33 (named after a ship) arrived at the draft office, they set the building aflame, destroying all the records. This was the catalyst that set off a five-day riot in which hundreds of people were killed, fires were set all over the city, and only the arrival of troops prevented the city's destruction. Fire companies, including the Black Joke, worked without sleep for days until all the fires were put out and, in some instances, also fought the rioters (while still defying the draft). Among the troops called to quell the riot were the New York Fire Zouaves; their most tragic loss occurred when their commander, Colonel Henry O'Brien was surrounded by the mob, shot several times in the head, and dragged through the street. Later two priests found his body and carried it to the "Dead House" at Bellevue Hospital.

Street fighting during the 1863 Draft Riots.

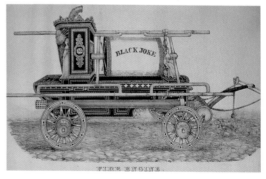

The "Black Joke," a typical New York-style gooseneck hand pumper of the 1830s.

A hose reel is decorated with the fire company's dramatic emblem.

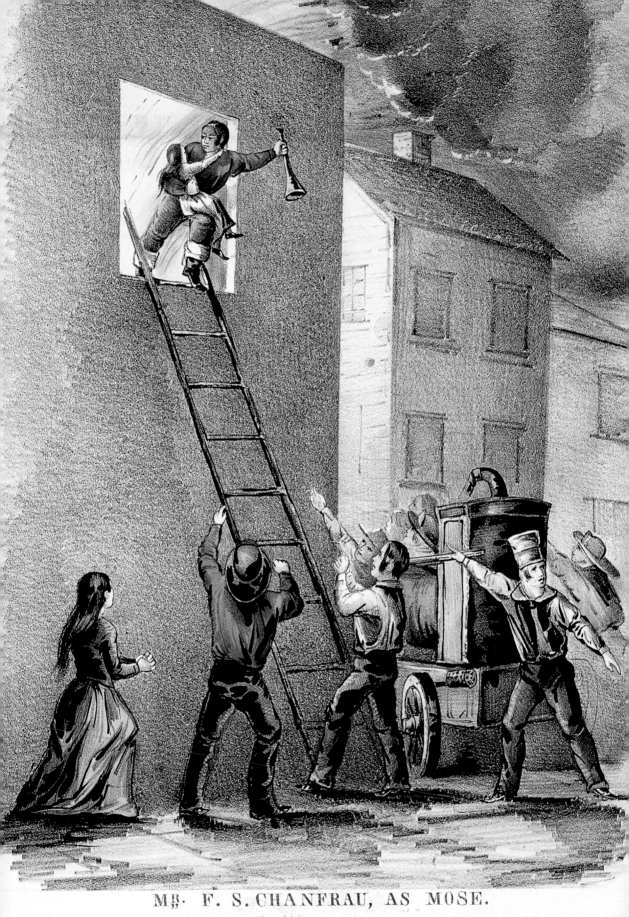

MR. F. S. CHANFRAU, AS MOSE.

rescuing the Child.

Fireman Mose

The character of Fireman Mose personified the rough-and-tumble world of firefighting in the 1840s. Here is his first appearance, from Asa Greene's 1848 play, "A Glance at New York."

Brass speaking trumpet with an unusually narrow bell.

Mose. (*Smoking; he spits.*) I've made up my mind not to run wid der machine any more. There's that Corneel Anderson don't give de boys a chance. Jest 'cause he's Chief Ingineer he thinks he ken do as he likes. Now last night de fire was down in Front Street, we was a takin' 40's water; I had hold ov de butt, and seed she was gittin' too much fur us; and I said I to Bill Sykes: "Sykesy, take de butt." Seys he, "What fur?" Seys I, "Never you mind, but take de butt." And he took de butt; so I goes down de street a little, and stood on 40's hose. Corneel Anderson cum along and seed me. Seys he, "Get off de hose!" Seys I, "I won't get off de hose!" Seys he, "If you don't get off de hose I'll hit you over de gourd wid my trumpet!" Seys I, "What!—I won't get off de hose!" And he did hit me over the gourd!

The actor F.S. Chenfrau as Fireman Mose gives advice to a street waif.

Left: *A daring rescue is performed on a New York stage in one of the "Fireman Mose" plays.*

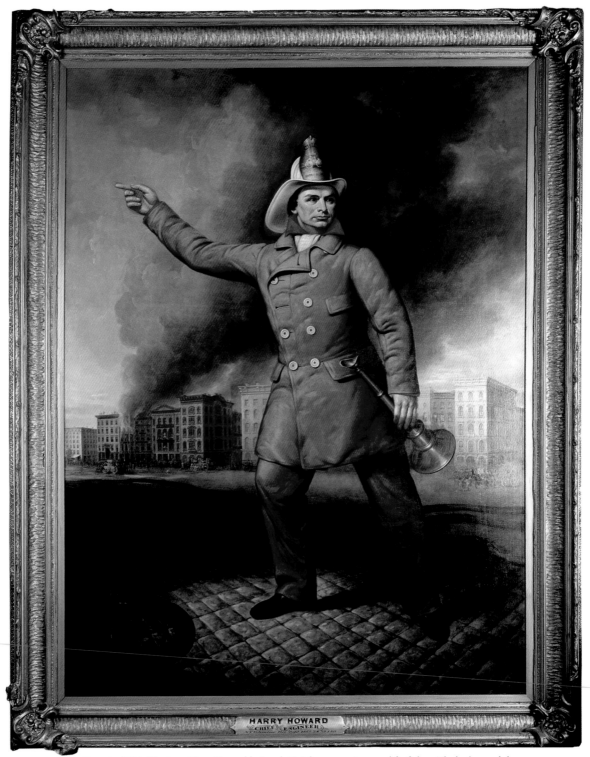

Portrait of Chief Engineer Harry Howard by Joseph H. Johnson, a painter and firefighter. The background shows the tragic 1854 Jennings fire in which 13 firefighters died, the worst toll in the history of the volunteer department.

HARRY HOWARD (1822-1896)

Chief Engineer Harry Howard personified all that was best about the volunteer fire department. Big and strong as a youth, he always showed more interest in the local fire company than his job as a cabinetmaker. He became a runner alongside Peterson Engine Company No. 15 and, as soon as he was of age, joined it as a full-fledged fireman, eventually rising to foreman. By 1850, the year he moved to Atlantic Hose Company No. 14 (better known as the "Bowery Boys"), his fire-fighting skills and reputation for bravery made him one of the best-known men in the department. That year Howard was elected to the important post of assistant engineer under Chief Engineer Alfred Carson. Using one of the first telegraph fire alarm systems, he was usually one of the first to arrive at a fire, where he led the fight until Carson arrived.

Politics and firefighting were inextricably linked during this era, and Howard's many daring rescues made him a natural candidate. While still fighting fires, he was elected assemblyman, alderman, and then receiver of taxes. In 1857, he ran for chief engineer on the Tammany ticket against Alfred Carson and defeated his superior. Before assuming office, he quit his political posts and insisted that his books be audited; investigators discovered that every penny was accounted for—he was one of the few honest politicians of the day.

Chief Engineer Howard's first act was to institute the practice of bunking at fire houses. He also had tall ladders placed at key points around the city and made other changes to improve the efficiency of the department. Like most firemen of his day, however, he fought against the introduction of steam-powered hose engines. He claimed that the jets of water they produced would be more damaging to property than fire. The real reason was that steam-powered engines would need fewer firefighters to extinguish fires. Nevertheless, thanks to Howard's dedication the number of fires drastically under his watch, and insurance rates dropped correspondingly.

Engineer's badge, circa 1857-60.

In 1858, while running to a fire Howard had a stroke and became partially paralyzed. Ironically, at the age of 36 he became a walking testament for one of his greatest campaigns: for firemen to be paid for their work. The volunteers exerted tremendous physical effort just to get to fires—the apparatus was mostly hand-pulled—and then risked their lives in putting them out. All just for the glory. In 1860, his debility forced Howard to resign from the department. He nevertheless spent the next 46 years as one of the F.D.N.Y.'s greatest advocates, encouraging the department to make many improvements in both technology and in improving the lives of firefighters.

FROM

2ND FIRE ZOUAVES

OF NEW YORK CITY

TO

FRIENDSHIP

3

OF LONG ISLAND CITY

The Fire Zouaves

The Fire Zouaves were Civil War (1861-1865) army regiments made up of volunteer fire fighters from New York City. The American Zouaves (pronounced zoo-ahvz) were modeled after the highly respected French Foreign Legion army in Algeria, which in turn took its name and elegant costume from the Zouaoua people native to the area, many of whom fought in its ranks. The Zouaves were popularized in the United States prior to the start of the Civil War by Elmer Ellsworth, who toured the country with an elite military drill unit. In April of 1861, Ellsworth turned to New York's firemen when he formed a regiment to fight in the war. Half the department joined, becoming the first volunteer

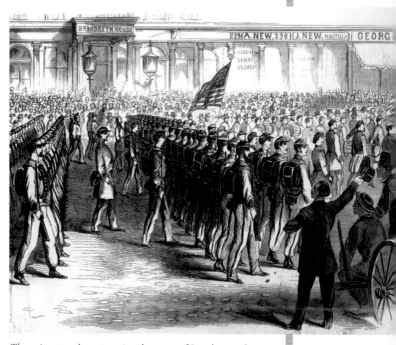

The regiment and escort passing the corner of Broadway and Canal Street, April 29, 1861

regiment on the Union side. The 1100 men were outfitted in custom gray jackets, gray flowing trousers, and red firemen's shirts. Many more firemen wanted to sign up, so the 2nd Fire Zouaves, officially known as 73rd NY Infantry, was formed soon after. In June of 1862, the First Fire Zouaves were disbanded after being decimated during the battle of 1st Manassas, also known as the First Bull Run. The Second Fire Zouaves served with the Army of the Potomac and participated in its campaigns from Yorktown in 1862 to Appomattox in 1865. Their total enrollment numbered 1350 and total casualties 711.

Left: *Presentation shield given by the 2nd Fire Zouaves to Long Island City's Friendship Co. 3. It was common practice among fire companies to exchange presentation shields as tokens of gratitude, friendship and esteem.*

THE LIFE O

The Metro

A FIRE MAN.

System.

A New Department

After the end of the Civil War, the city's leaders finally decided that the volunteer firefighters were doing more harm than good. Insurance companies, businesses, and property owners complained that the volunteers were not giving proper protection; their long list of grievances included institutional violence, resistance to change, and the embezzlement of department funds, not to mention inciting the Draft Riots. They argued that it would simply be cheaper for the city to establish a paid department. Although the city was then ruled by a Democratic mayor, the real political power lay with a group of wealthy reformers allied with the Republican-controlled state government. In March of 1865, they pushed through the state legislature "An Act to Create a Metropolitan Fire District and Establish a Fire Department Therein."

Presentation shield (c. 1850) given by Lafayette Engine Co. 9 to Protection Co. 2, both volunteer companies in Williamsburg, Brooklyn.

The creation of this new organization, the Metropolitan Fire Department, was only the first step in a process that would make firefighting in New York the mission of a smaller but more effective department. By this time, many other cities had adopted the "Cincinnati system" which used paid firefighters, horse-drawn vehicles, and steam engines to pump the water. Although New York owned some steam engines, its department still used human power to pull its engines and pump most of its water. The organizers of the Metropolitan Fire Department moved as quickly as possible to update the department's equipment. Elisha Kingsland was appointed the first Chief Engineer of the paid department, and from July 31 through December 1, 1865, new companies of paid firemen went into service as the volunteer units were phased out. By early 1866, the city had paid firefighters organized into 34 engine companies and 12 ladder companies, equipped with steam engines, horses, and a telegraph system for communication. Unfortunately, the officers and men were just beginning to learn how to work together, and a number of serious fires-coupled with rising insurance costs-made many New Yorkers doubt the value of the new system.

Metropolitan Fire Department badge, circa 1865-70.

Both the rate of improvements and public confidence in the new department increased after Alexander T. Shaler, a retired Civil

A red wool firefighter's shirt from the 1850s.

War general, became President of the Board of Fire Commissioners in 1867. Under his leadership, new apparatus (principally Amoskeag steamers) were acquired by the department, and the men were permitted to ride on the rigs when responding to alarms. More importantly, Shaler demanded military-style discipline and set rules of conduct and other regulations intended to enhance the department's efficiency. Companies were organized into battalions; drills and marching in formation for parades were instituted; stricter uniform regulations were introduced; and a "department store" was created as a part of a system to improve the distribution of supplies. Higher standards were set in recruiting officers; classes of instruction for officers

Red wool volunteer firefighter's shirt.

were begun in 1869; and the promotion of officers was now based upon competitive examinations before a board of department officers and the fire commissioners.

The benefits of these changes quickly became apparent. In 1866, the losses by fire in New York City totaled $6,428,000; three

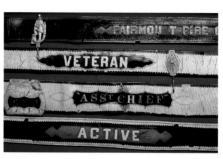

years later, that figure had fallen to only $2,626,393. This improvement was achieved with a mere 599 firefighters (compared to a volunteer force of 3,421 men in 1865). To a great extent, these gains were accomplished through the use of steam power and horses, allowing the work to be done with fewer men. The new rules and regulations, however, were also important. In General Shaler's words, greater discipline and professionalism meant that 12 men could "quietly accomplish" what "fifty formerly accomplished by muscle and competition.".

Belts were part of the decorative parade attire of mid-19th century firefighters.

These changes came at an opportune time for New York City. Local merchants and financiers had become heavily involved in the opening of the western frontier. Raw materials like lumber, coal, iron, and grain were pouring into the city's docks, while merchants made millions selling manufactured goods to the western settlers. This economic boom fueled one of the city's greatest periods of expansion. Streets were

Wool volunteer firefighter's shirt with blue piping.

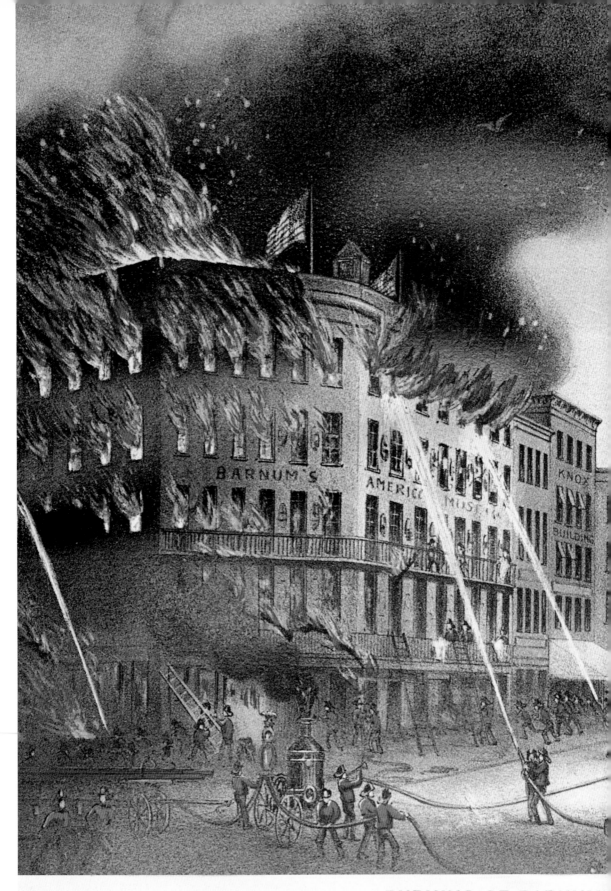

BURNING OF BARNUM'

AFTER THE ORIGINAL PAINTING BY C. P. CRANCH, BY PERM

Barnums Museum Fire

P.T. Barnum's Museum was one of the city's most famous attractions. Unfortunately, it was also one of the most combustible. On December 24, 1872, it burned for the third time in less than 10 years. Afterward, Barnum decided to concentrate his energies on his circus and never rebuilt the museum.

"At 4:10 o'clock yesterday morning, as Patrolman Raymond, of the Fifteenth Precinct Police, was on duty on Fourth-avenue, near Fourteenth Street, his attention was attracted by cries of "Fire." He ran down Fourteenth-street toward Third avenue, and when he arrived opposite Barnum's Museum he found volumes of smoke issuing from the building. An alarm rap soon brought to his assistance several officers from the Fifteenth and Eighteenth Precincts. The doors of the building were forced open, and the Police found that the whole of the rear portion of the premises was on fire. An alarm was immediately sent out by telegraph to the Fire Department, and this was quickly responded to. Hook and Ladder Company No. 3 was the first to arrive, and was promptly followed by Engine Companies Nos. 5, 14, 33, 25, and 18, and Hook and Ladder Companies Nos. 9 and 7. District Engineer Benjamin Gicquel took charge of the companies as they arrived on the ground, and, placing the steamers in the most advantageous position, in a very short time had several streams of water playing on the fire.

Owing to the highly combustible nature of the building, constructed as it was of wood covered with corrugated iron, and the inflammable nature of the fittings and contents, the flames spread with great rapidity, defying all the well-directed efforts of the firemen to keep them in check. By the time the firemen arrived on the ground the interior of the edifice was in flames, and the fire was spreading along the roof beams. An effort had been made by the Police and the keepers to rescue some of the valuable animals on exhibition in the menagerie.

This was only slightly successful. Two of the elephants, known as "Jennie" and "Sam," were unchained and led out without any serious difficulty. The elephants were very much frightened at the fire and smoke, and appeared to be completely cowed by the fear which had taken possession of them. After they reached the street they were hurried to a stable in Eleventh-street, where the horses attached to the circus are kept. The camel was next rescued and taken to the stable, and these three are all that are left of the splendid collection of animals which had taken years to bring together. As the flames reached the cages occupied by the lions, tigers, and leopards, their screams and roars echoed through the night air."

The New York Times

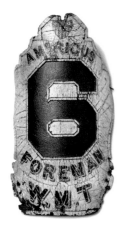

William Macy "Boss" Tweed wore this front plate on his helmet when he was foreman of Engine Company 6.

Insurance company's fire mark sign.

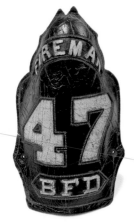

Late 19th century helmet frontpiece from Engine Co. 47 of the Brooklyn Fire Department.

built to fill out the city's grid plan above 42nd Street; underground, the city installed hundreds of miles of new gas, water, and sewer pipes. New railways opened the development of the Upper East Side, while mansions rose along Fifth Avenue. In Lower Manhattan, where space was tight, a recent invention called the elevator allowed builders to maximize the vertical possibilities of their lots. The old limit had been five stories; now office buildings rose six, seven, eight, and even 10 stories.

*A*t the same time, the city's reformers were determined to use science and good management techniques to improve life for all citizens. The reorganization of the fire department was just the first step. New health regulations were instituted that lowered the incidence of infectious diseases, while building codes were passed to stop the construction of the warren-like tenement apartment buildings that were home to many city residents. Perfect environments for disease, these tenements offered almost no light or ventilation, no fire escapes, and frequently flooded during rains. If the city could reduce the number of tenement fires, dozens of lives could be saved every year.

Unfortunately for the reform movement, by 1869 William Tweed and his Tammany Hall-controlled Democratic Party had overthrown the Republican state government. Tammany politicians already occupied the mayoralty and the governorship; now they controlled the state legislature. In 1870, Tammany Hall obtained a "home rule" charter for New York City that gave the city government much greater political power. New Yorkers found that Tammany politicians were not necessarily anti-reform; they were just more interested in personal profit. The tenement codes remained on the books, for example, only now it was much easier to bribe an inspector to look the other way. Tammany's plans for the fire department sounded more dramatic than they were. They abolished the state-created Metropolitan Fire Department and replaced it with the new, paid Fire Department of the City of New York. In practice, however, the two departments were nearly identical, because the new department kept most of the innovations that had been instituted in the preceding five years. Only

THE BROOKLYN THEATRE FIRE

Built largely of wood and filled with flammable materials, theaters were dangerous firetraps during the 19th century. The metropolitan area's worst theater fire occurred in December of 1876, when nearly 300 people died during a performance of "The Two Orphans" at the Brooklyn Theatre. A. L Frodeau was one of the few men who escaped the theater's upper balcony during the fire:

"I live at No. 257 Columbia Street, Brooklyn; am a jeweler by trade, and eighteen years of age; I was in the gallery with my sister last evening; I at first thought the noise and confusion on the stage were part of the play; one of the actors told us to keep our seats, and in a moment Mr. Studley the actor told us to fly for our lives. All then rushed to the door, one on top of the other. The people piled up in a heap in the gang-way leading to the stairs. I fell exhausted and left at least two hundred people behind me. I had pushed my sister on before me until I fell, and was walked on. In less than five minutes from the time the fire commenced the way and the gallery were in a blaze. If the passage had been twice as large we could not have got out for want of time, the fire came up so quickly from below. My face was pounded to a jelly by

boot-heels, and is badly bruised, as you see. I do not remember how I got down stairs. I was insensible, and must have been carried down or picked up. The women screamed, and the men shouted and cried out for help in the crush. The gush of flames came through the dome in an instant. My sister is still missing, but I hope she is safe. We were alongside of each other when I last saw her. There was a young man alongside of me, also, and I believe he is missing. More people could have got out from the gallery if they did not crowd so on top of each other. It could not have been five minutes from the time I saw the fire until I was suffocated with smoke and flame, and then knocked down and trampled on; after that I became unconscious, and the next I knew I was at the Station-house; I cannot tell how I got there."

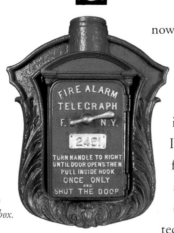

The cover of an early 20th century alarm box.

now there were a few more no-show jobs, while new equipment contracts usually included a little something extra for the Tammany bosses.

In the decades after the Civil War, increased immigration rapidly swelled the city's population. It became crucial that firefighters both get to fires faster and have effective equipment when they arrived. The most dramatic improvements that the department made were in the areas of firefighting technology. One of these innovations was a more powerful steam pumper that could throw larger quantities of water longer distances. The department also experimented with a self-propelled Amoskeag steamer in 1872. Rubber and cotton-jacketed hose replaced the old-style leather version. In 1875, the city purchased its first true fire-boat, the William F. Havemeyer, to protect the busy waterfront. The increasing height of structures in New York (thanks in part to the growing use of elevators) led the department to start buying water towers and, in the 1880s, the French-invented scaling ladders. A fatal 1875 accident with an aerial ladder caused the FDNY to avoid purchasing that piece of equipment until around 1890. Firefighters needed training to use all this new technology, so in 1883 the department opened the School of Instruction, with classes for both probationary and veteran firemen.

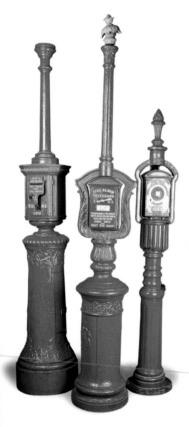

Two early 20th century alarm boxes (left) and one 19th century alarm (right).

The department's communication equipment was also regularly improved. In 1870-71, the City added alarm boxes to the telegraph system. These first boxes, however, were locked; only certain "responsible" people had keys that allowed them to open an alarm box and pull the activating handle inside. Keyless boxes were introduced in 1881, allowing any citizen to report a fire. The next year, the first telephones were installed in fire department buildings. During this era, the speed with which firefighters could react to alarms was enhanced by other innovations such as the sliding pole and quick-hitch harness for the horses. By the last decade of the 19th century, the horse-drawn, steam-powered fire department was reaching the highest level of efficiency it could possibly achieve.

FIREHOUSE PETS

One of the famous cats of the Fire Department was Barney, of Engine Company No. 59. Barney's great feat was sliding down the pole in the fire-house, and he did it as gracefully as any member of the company. True, he did not come down with a rush like the men, but he would wrap his four paws around the brass rod and let himself down with great rapidity. Sometimes the firemen would play a trick on Barney by placing a dog at the foot of the pole. The cat would immediately notice this and stop half-way down. He would carefully take his bearings, watch for an opening, drop on top of the dog, scratch him once or twice, and the rush to the cellar. Barney could play watchman also, and he would guard the engine-house to the best of his ability whenever the company was out on fire duty.

One of Barney's friends in this fire-house is a fine Dalmatian, who is a genuine hero. Three times he was run over by the engine, and on each occasion the veterinary surgeon had to sew him up. He often followed a trolley on which his captain traveled to his meals, from One Hundred and Thirty-Ninth Street and Lenox Avenue to One Hundred and Sixteenth Street and Lenox Avenue. He would get on and off the car while it was in motion whenever he liked. He would to into burning buildings, no matter how hot or smoky, and he was always to be found near the pipe where the men do their heaviest work. At one fire, a few years ago, it is a matter of record that he climbed a regulation Fire Department ladder. He

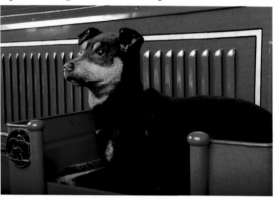

For 10 years, this dog was the mascot of Engine Co. 203 and known for running into burning buildings to look for victims. After he was tragically killed by a car in 1939, the fire company had him stuffed as a sign of their gratitude to him.

went up one story, and then entered the building through a window, the sashes of which were burning on both sides. The owner of this dog, an officer in the Department, said of this: "You might think these are 'ghost stories' that I am giving you; but I assure you they are facts, and can be proved any time you wish it."

From "Fire Fighters and Their Pets" by Alfred M. Downes, Harper Bros., New York 1907

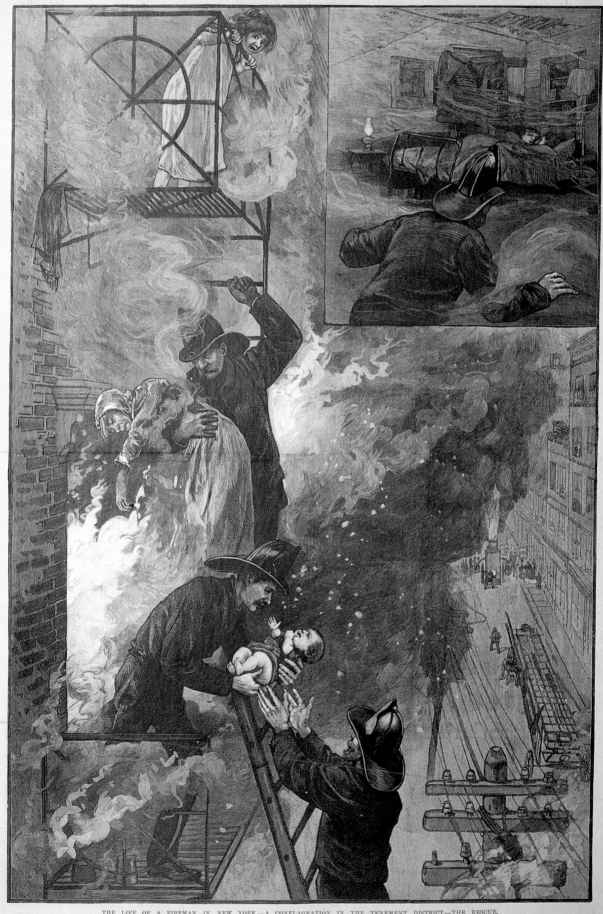

THE LIFE OF A FIREMAN IN NEW YORK.—A CONFLAGRATION IN THE TENEMENT DISTRICT—THE RESCUE.

FROM A SKETCH BY A STAFF ARTIST.—SEE PAGE 155.

FIRE ALARMS

New York's firefighters have always recognized that rapid response is crucial to putting out fires. From 1845 to 1873, watchmen manned eight fire towers around the city and kept a 24-hour vigil. When they saw signs of smoke or flame, they rang a bell, signaling to the firemen to rush out with their engines. This system was an improvement on the earlier, haphazard methods, but it was still tremendously inefficient: Firefighters only knew that there was a fire somewhere in their district, so they had to race around, sometimes for an hour or more, trying to find it. By 1853, the eight towers were connected to a central office by telegraph, and from there the signals were sent on to the city's firehouses. But the problem of accurately locating the fire remained.

Then a Boston physician and fire buff named William Channing invented a system to send telegraph alarms from every street corner. Inside his alarm box was a crank which when turned sent a coded telegraph signal (the number of the alarm box) to the central alarm office. From here, the alarm was relayed to the nearest firehouse, where the ringing of a bell told them which box had sent the signal. By 1870, 346 of these boxes were installed below 14th Street, while the keys were given to the police, storekeepers, and other respectable citizens. Their success was immediate; within a few years the watchtowers were closed, and the alarm boxes had spread to nearly every neighborhood. In the 1880s, the keys were discontinued, so anyone could call in an alarm, and the boxes were topped with gas lanterns.

For the next 100 years, telegraph alarm boxes were an important, and frequently elegant, part of the city's street decor.

By the late 1960s, the FDNY realized that the ringing of telegraph bells was not enough. The staggering numbers of alarms coming in from many poor neighborhoods included not only real fires but thousands of prank false alarms. In 1970, the department installed the new Voice Alarm system in Manhattan (and eventually the rest of the city) allowing the dispatcher to give firehouses crucial details of the call. The next year, the FDNY began experimenting with the ERS (Emergency Reporting System) box which allowed for two-way communication between the dispatcher and the civilian making the alarm. The dispatcher could now more quickly receive information about the emergency and dispatch the appropriate apparatus. In 1977, the department installed its first Computer-Aided Dispatch (CAD) teleprinter in a Brooklyn firehouse; today, a more advanced CAD system is basic equipment in every firehouse.

The last vestige of the telegraph alarm system was removed in 1983, when the department turned off the bells in every firehouse. Today, the vast majority of alarm calls, over 95 percent, come in over telephones, including pay phones, home phones, and cellulars. Street corner alarm boxes still operate in some neighborhoods, but these are now almost all the less attractive ERS boxes. We have gained in efficiency but lost a bit in style.

Left: As seen in this 1887 illustration, tenement fires were one of the many challenges faced by New York's firefighters.

Ribbon from a meeting of The Exempt
Firemen's Benevolent Fund, 1898.

COVERING MORE GROUND

In 1894, the citizens of New York City and the surrounding communities of Brooklyn, Queens, and Staten Island, along with the eastern half of the Bronx (the city had annexed the west Bronx back in 1874), embarked on a vast civic experiment. They voted to become part of Greater New York City, a merger they hoped would allow the metropolitan area take its rightful place as the nation's pre-eminent city. This consolidation, which became official on January 1, 1898, would also have a profound effect on New York firefighting.

*I*n one stroke, the area protected by the FDNY grew by 252 square miles, running from Lower Manhattan's bustling financial district to the farmlands of rural Staten Island. Some volunteer fire companies remained in service in the more far-flung areas (a few still fight fires today), but the FDNY took control of the vast majority of city firefighting. It was now by far the nation's largest fire service, taking over the Brooklyn and Long Island City paid departments, along with numerous volunteer departments across the outer boroughs. The old, three-member Board of Commissioners was replaced by one Fire Commissioner appointed by the Mayor, in the hope that this would reduce political interference. The FDNY had expanded to meet new needs, but the challenges were now far greater than its firefighters realized.

New York City in 1898 was far different from the city it had been 20 or even 10 years earlier. Consolidation obviously meant that the horse-drawn fire engines had to cover far more ground

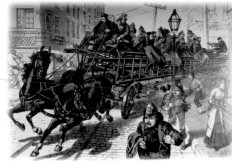

Pedestrians beware: a 19th century
ladder rushes to a fire.

than before, but this was a relatively minor problem. The real danger came from the city's explosive growth, not just horizontally but vertically. Manhattan, which had once been constructed of wood and brick, was now made of steel and stone. The Financial District was now crowded with the first skyscrapers, reaching 10, 20, and even 30 stories tall. Screeching elevated trains carried thousands of passengers every day over the main avenues, while the first motor cars were frightening horses on the street below. The port was the world's busiest, with docks lining the

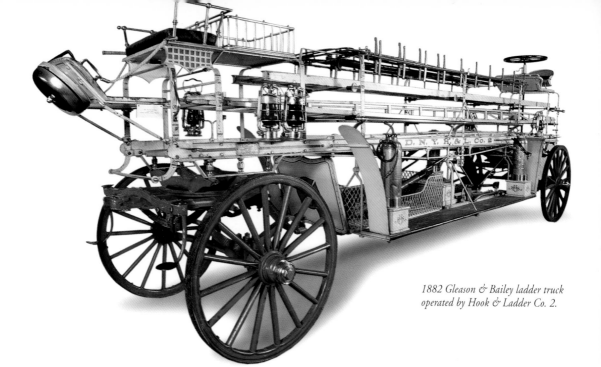

1882 Gleason & Bailey ladder truck operated by Hook & Ladder Co. 2.

East and Hudson River shorelines for miles; to cross the rivers, engineers planned bridges and tunnels linking Manhattan with Brooklyn and New Jersey. New York City was the most dynamic, modern, and impressive city in the world. But unfortunately, most of these technological achievements were built with little thought to protecting the structures-and even less to the lives of the people who used them-from fire and other disasters.

These dangers were graphically illustrated on the stormy night of December 4, 1898. Embers from a building fire in Lower Manhattan blew across the street and set ablaze the new, "fireproof," 16-story Home Life Insurance Building. Although this structure had interior stand-pipes for connecting to the hoses, firefighters were forced to retreat from the building when the fire spread. Instead, they had to carry their heavy lines to the top of an older, neighboring building and spray the structure from there. The Home Life Insurance Building burned all night, sending sparks throughout the neighborhood; meanwhile the first building to burn had already collapsed and burned itself out. For Chief of Department Hugh Bonner, this fire seemed to prove a prophesy he had made a few years earlier: "A fireproof building is more dangerous in itself and to the surrounding structures than the old-fashioned structure."

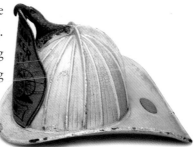

An assistant chief engineer of the volunteer period wore this white-painted high-eagle style leather helmet

Ladder Rescue, 1899 Windsor Hotel Fire, A Captain's Story

We rolled on the third alarm with Truck Company Number Twenty-One—the hook and ladder. On the way we could see that we were facing a terrible situation. The third alarm had rung within five minutes, which indicated a fire of tremendous extent. As we came down the Avenue the dense crowd in the streets, due to the parade, hindered us at first, but the people soon made way. We were ordered to swing into Forty-Sixth Street, at the south end of the hotel. At this time people were being rescued on the Fifth Avenue front of the building, but in all that long seven- story-high brick wall on the Forty-Sixth Street side of the building there was but one face—that of a woman away up on the seventh floor.

The battalion chief in charge of that immediate section of the fire ordered us to send up our ladders at once. The fire by this time had gained tremendous headway. Behind the front, in all that section of the building, flames were leaping upward. We sent up a sixty-five-foot ladder, the longest we had, but that only reached up between the fourth and fifth stories of the hotel. Up went the rescuers to save that woman's life, the one human being who seemed to be left alive on that side of the building. After the men had started up the ladder I went up myself, and gained a foothold for the time being on the ledge of a window on the fifth story. It was fortunate that I did so. There was little smoke, but the flames were roaring through the hall behind the wall. I had seized two scaling ladders from the truck, and passed them up to the two men assigned to the rescue work. As soon as they reached the tip of the sixty-five-foot ladder, one of them climbed the next two stories by means of these scaling-ladders. Let me say now that in all my experience as a fireman I never saw a better rescue, nor do I believe that I shall ever see as good a one as this if I remain in the Department for another quarter century.

When the rescuer reached the tipmost round of the ladder, he began to work with the scaling ladders. One of them he jammed through the plate-

glass window on the sixth floor, and, climbing up, he thrust the hook of the other ladder through the window of the seventh floor, where the woman waited in awful suspense. He reached her, and, aided by his comrade, began to carry her down. Behind us blazed the fire. The only path to safety was down the sheer wall of the hotel. It was slow, breathless work, and it seemed to me, sitting as I was on the ledge of the fifth-story window, that hours and hours must have elapsed before the rescuer could descend from the seventh to the fifth story with his burden of human life. The strain was intense, but it really was a matter of seconds.

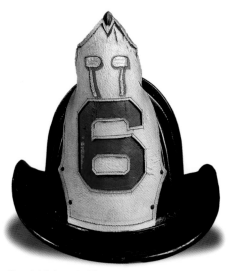

Captain's helmet, Ladder Co. 6, early 20th century.

J ust as they were reaching the point where I was waiting to aid them the lower rung of the lowest scaling-ladder broke, and the section of the ladder below it fell to the street. I seized the rescuer and steadied him. There we were on this window-ledge trying our utmost to save the woman's life, and the truth is that she was not wasting her energies by giving them man who had her in charge any particular

aid. In one hand she held a bag of jewels, in the other her pocket book. I urged her to give me both the jewel-bag and the pocket-book; but even in that crisis it took some time to convince her that I would give the pocket-book back to her after she had reached the street. The jewel-bag she would let go at all. And all the time she wailed over the pet dog which she had been forced to leave behind, and begged me to go and get it. I told her that she herself must be saved, and helped the fireman who made the rescue to get her upon the sixty-five-foot ladder, at the tip of which were all working. Then she was carried safely to the street. [The dog was shortly saved.]

From "Fire Fighters and Their Pets" by Alfred M. Downes, Harper Bros., New York 1907

Battalion Chief's badge from the Newton, Queens fire department, late 19th century.

Military style hats and uniforms were adopted by fire departments in the latter part of the 19th century. This cap was worn by a member of the Flatbush Volunteer Firemens' Association, c. 1890.

Brooklyn Fire Department firefighter badge, late 19th century.

The old, non-fireproof structures, however, remained the most lethal, both in the city's vast tenement districts and in the fancier districts uptown. On St. Patrick's Day of 1899, the guests in Fifth Avenue's Windsor Hotel were viewing the famous parade when a carelessly tossed match lit a curtain. Within minutes the hotel was on fire, helped by the lack of fire walls and the abundant woodwork of the interior. Firefighters, including many in the parade, rushed to the scene. The engines, however, were slowed by the crowd, and by the time they arrived guests were already jumping from the windows. The firemen performed many heroic rescues, often with relays of scaling ladders, but were unable to slow the course of the flames. Soon, the totally engulfed building began to collapse, killing dozens of guests trapped inside. By the end of the day, 45 civilians had died in a fire that firefighters were largely helpless to stop.

From Chief Bonner on down, the leaders of the FDNY understood the challenges they now faced. They had to find more ways to prevent fires from even starting, and they had to improve both their efficiency and the technology they used in fighting fires. Unfortunately, the climate in the larger city was not always amenable to change. As always, politics was a factor (although firemen were not nearly as politically involved as in the volunteer era). When the Tammany political machine was in power, it hobbled the FDNY with patronage appointments, and it became harder to implement necessary changes. When political power swung back to the reformers, the department generally became more efficient, and it was easier to introduce technological innovations and pass much-needed legislation.

One of the main forces for change was Hugh Bonner's successor, Edward Croker, who surprisingly was the nephew of the notorious Tammany boss Richard Croker (who had first entered politics as a volunteer fireman). Although his

FIRE HORSES

N o horses in the world are treated better than the fire-horses. The men themselves take particular pride in them, and there is trouble for any one who maltreats them in any way. Rigid rules are made to protect their health and comfort, and any violation of these rules, no matter how slight, is met with swift punishment. As much attention is given to the fire-horse in preparing him for his work in the Department as the trainer devotes to a thoroughbred racer. Fire-horses average from seven to fifteen years' service, according to the territory in which they work.

In many cases, as some of the older officers and men of the Department well know, commanding officers have become so attached to their pets that rather than report them unfit for further service, they have risked having charges preferred against themselves for failing to respond to alarms as promptly as they should, and have taken the blame up their own shoulders, when the fact was that the horse

could no longer maintain the pace necessary to bring his company to the fire-hydrant in time. . . Many a fireman, who from overwork and fatigue has fallen asleep at the patrol desk in the small hours

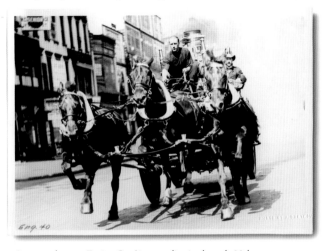

Steam and sweat: Engine Co. 40 responding in the early 20th century.

of the morning, has been saved from punishment for neglect of duty by an intelligent horse who, springing forward as the electric signal comes, dashes to the patrol desk and awakens the sleeper. While the firemen may enjoy a practical joke on their fellow members, the horse is always safe from their teasing, for to them he is the ever faithful friend and comrade.

From "Fire Fighters and Their Pets" by Alfred M. Downes, Harper Bros., New York 1907

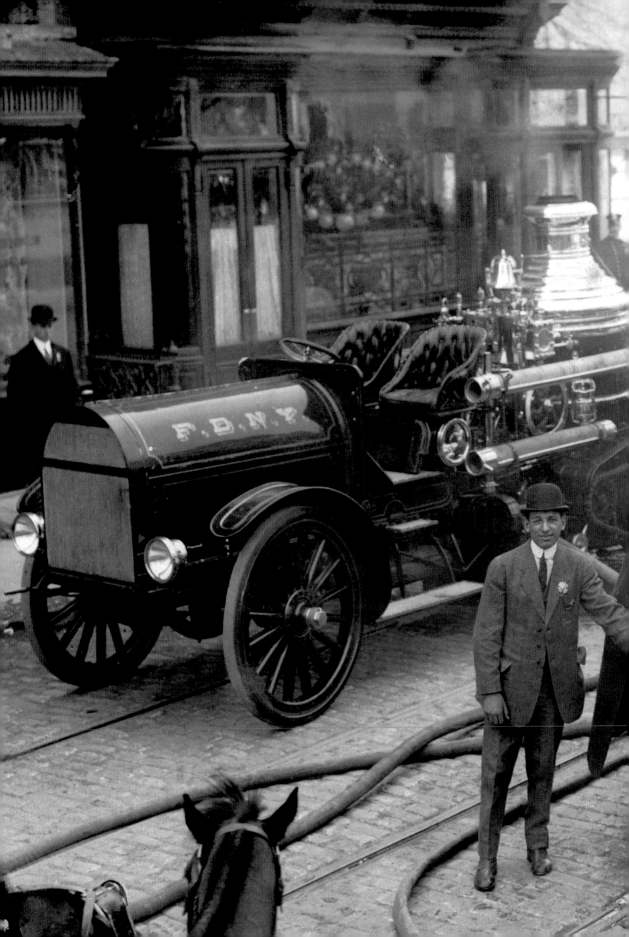

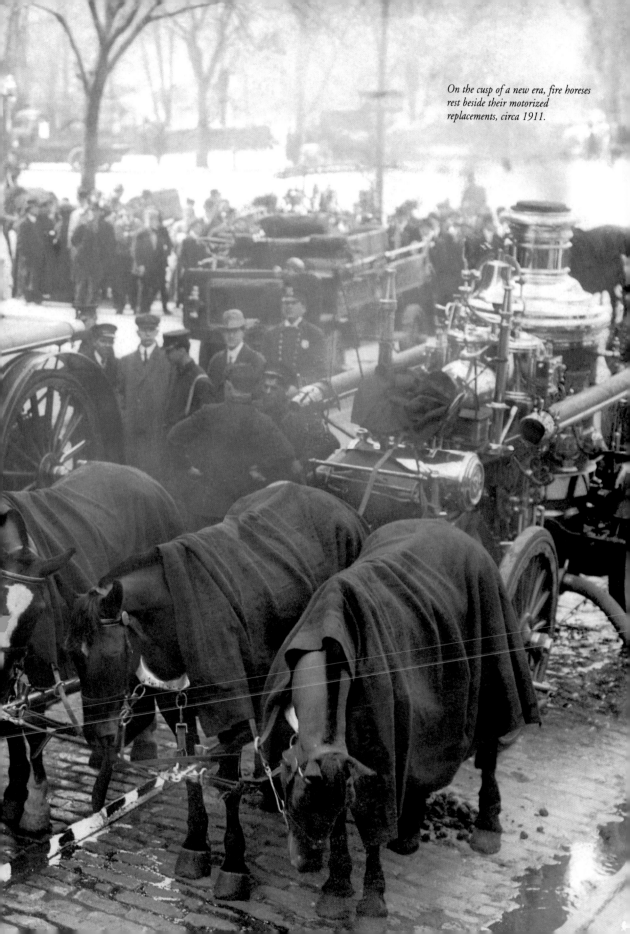

On the cusp of a new era, fire horses rest beside their motorized replacements, circa 1911.

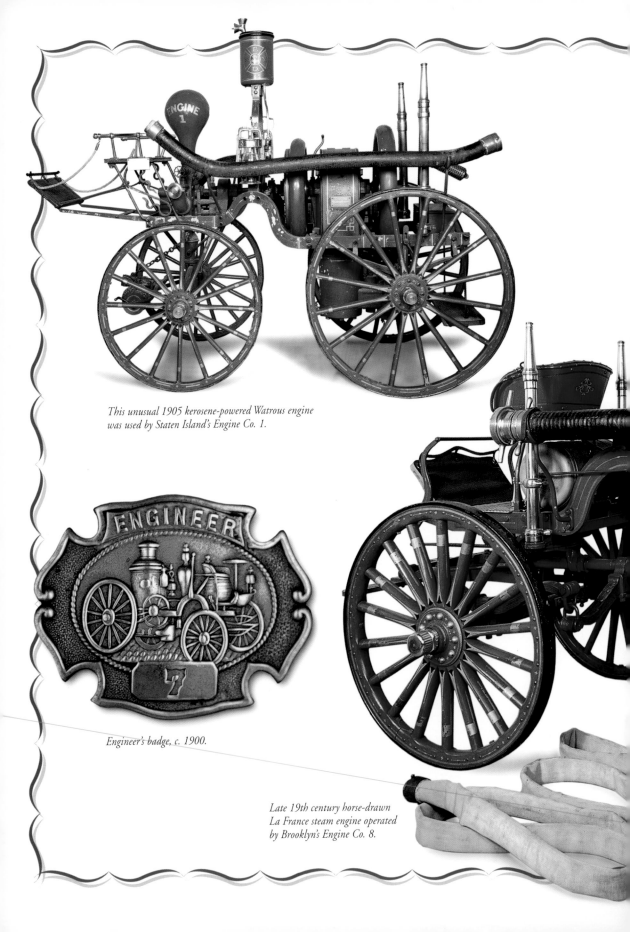

This unusual 1905 kerosene-powered Watrous engine
was used by Staten Island's Engine Co. 1.

Engineer's badge, c. 1900.

Late 19th century horse-drawn
La France steam engine operated
by Brooklyn's Engine Co. 8.

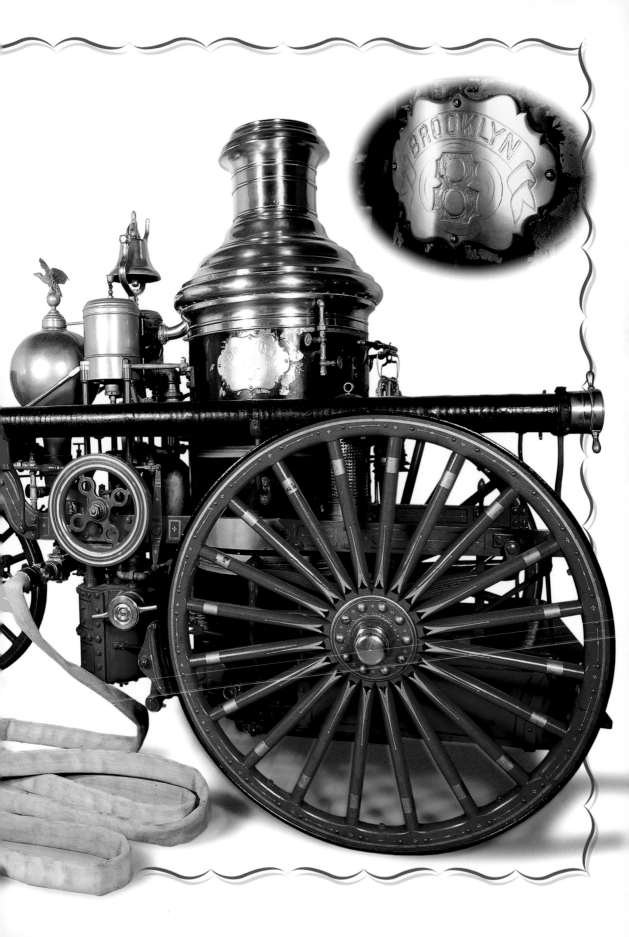

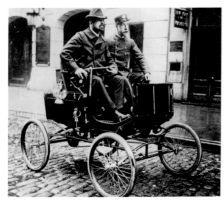

1901: Chief Croker (right) races to a fire in his new Locomobile.

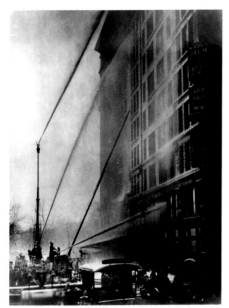

Hoses play on the Triangle Shirtwaist fire.

uncle likely helped him get the job, Chief Croker was already highly respected by his firefighting brothers. From 1900 until 1911, he became the FDNY's most important leader. He strengthened the department's efficiency and military-style discipline; he purchased the department's first motorized vehicle, a 1901 Locomobile, to help him get to fires; and he lobbied for stand-pipes in all tall buildings and a high-pressure water system for Lower Manhattan's skyscraper district. In 1910, Croker proposed the formation of a fire prevention bureau to address the dangers of fires in factories, warehouses, and office buildings. Unfortunately, Tammany was then in charge (although Boss Croker had long ago "retired" to England), and business owners and big landlords managed to get the fire prevention proposals squashed and even smeared Chief Croker with rumors of corruption.

*T*ragically, Chief Croker's worst fears were realized a few short months later. In 1911, the owners of the Asch Building near Washington Square believed that their building met and even exceeded the requirements of the building code. Then, near closing time on March 25th, a pile of rags began to smolder in the ninth floor factory of the Triangle Shirt Waist Company. Within 30 minutes, New Yorkers learned how inadequate those building codes really were. Although the Asch Building was "fireproof," the factory was filled with highly flammable materials which exploded into flames. The fireproof ninth floor doors were locked (to prevent employee theft); the fire escape tore loose from its fastenings as soon as the first people stepped onto it; and the workers, almost all young immigrant women, saw no choice but to leap to their deaths. The fire engines quickly arrived, immediately deployed ladders and high-pressure hoses, and declared the fire "under control" within 18 minutes. By that time, however, it was too late for the 146 victims who died that day.

Nearly every person who had anything to do with conditions in that building, including its owner, the architect, the factory owner, and the building inspectors, steadfastly refused responsibility

for the blaze. Nevertheless, outrage over the fire, and over those denials, shook New York City and helped topple the Tammany administration in the 1912 elections. Although Chief Croker retired in August of 1911, his successor, Chief John Kenlon, was able to turn many of Croker's proposals into realities. Fire department advocacy led to a New York State labor law mandating sprinkler systems in all factories. The Fire Prevention Bureau became a reality and advocated protection of life first and then protection of property. Building codes were made tougher, and the FDNY was finally given a much greater role in determining whether both residential and commercial buildings were safe.

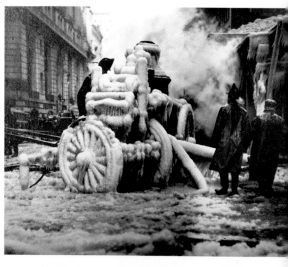

*U*nder Chief Kenlon, the FDNY began the great change to a motorized department and the gallant fire horses began to be retired. Back in 1909, the department had purchased its first motorized fire engine, a gas-powered Knox high pressure hose wagon. In 1911, Kenlon bought the second, a gas-electric ladder truck that was not very fast but could pull. After the reform administration took over in early 1913, the FDNY began buying motorized fire engines by the dozen, almost all of them gas-powered. These included Ahrens-Fox, Robinson, and American LaFrance pumpers; Christie and Van Blerck tractors; and Mack and South Bend hose wagons. The department particularly liked the American LaFrance Type 75 pumper, and several hundred of them entered service during the late 1910s and 1920s. Brooklyn's Engine Company 205 made the last run by a horse-drawn FDNY on December 20, 1922.

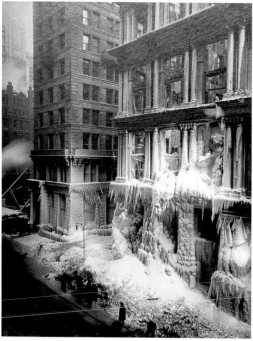

Top and Bottom: *Scenes of the tragic 1912 Equitable fire.*

New York City was nevertheless changing faster than the department could keep up. Three new bridges now spanned the East River, while the high-rise district was spreading rapidly

FIREBOATS

Fires along New York City's rivers and vast waterfront have always been one of the FDNY's greatest challenges. Boat and pier fires are hard to reach, hard to put out, and frequently involve some combination of dangerous materials. In the early years, the volunteer fire department could often only look on helplessly while ships burned to their waterlines.

In 1800, the volunteers constructed their first "fireboat," actually a barge carrying a hand-powered pumper. The boat was so cumbersome-it had to be rowed to fires-that it was of little practical use. After it was decommissioned in 1818, the fire service waited 48 years before again venturing on the water. During this time, the port of New York grew to the world's busiest, home to thousands of steam- and sail-powered vessels carrying goods and passengers all around the world. In 1866, the Metropolitan Fire Department hired a tugboat named the John Fuller and outfitted it with fire-fighting apparatus. Nine years later, the FDNY christened the William F. Havemeyer, the city's first fireboat built specially for the task, which carried two Amoskeag steam pumpers. This boat performed so well that by 1900 the FDNY had seven steam-powered fireboats stationed on the river.

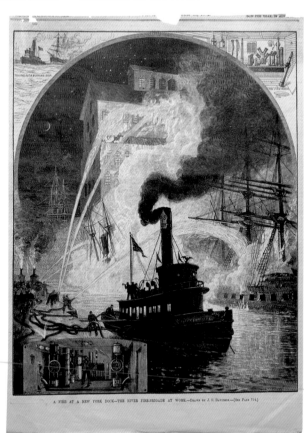

A FIRE AT A NEW YORK DOCK—THE RIVER FIRE-BRIGADE AT WORK.—Drawn by J. O. Davidson.—[See Page 714.]

The William Havemeyer, *New York's first true fireboat, fights a dock fire.*

Although the FDNY's fireboat fleet performed bravely at numerous fires, the grim reality was that most boats turned into firetraps if set ablaze. In 1904, a wooden steamship called the General Slocum was packed with over one thousand factory workers enjoying an excursion. The boat caught fire on the swift currents of the East River, and unaccountably, the captain kept steaming ahead rather than stopping or running the boat aground. The Zophar Mills fireboat gave chase but could not catch up, and within minutes 1,030 people were dead. It remains the second highest death toll from any disaster in New York City history.

At its peak, the FDNY's Marine Division had 10 fireboat companies stationed at various piers around the city. These boats performed essential work during the two world wars, when the port was filled with troop and supply ships often laden with explosives. The largest fireboat was the Fire Fighter, launched in 1938, which could pump a phenomenal 20,000 gallons per minute of water. In 1943, the crews of the Fire Fighter and its sister ship the John J. Harvey tied their lines to the burning El Estro cargo ship, which was filled with bombs, depth charges, and aviation fuel. It carried enough explosives to destroy New York harbor if it went off. While New Yorkers stayed away from their windows for fear of flying glass, El Estro was towed out to sea and safely scuttled.

After the 1950s, traffic in the port began to abate, while containerization made shipping far less vulnerable to fire. Although the fireboats had a spate of work due to fires on abandoned piers, their services were generally less and less needed. The nine-boat fleet of the 1960s was cut back to four boats and two spares in the mid-1980s and then three active boats in 1991. The FDNY then began to experiment with smaller, faster boats, not all of which proved satisfactory. With port fires down drastically, the Marine Division seemed ripe for the budget cutter's axe. Then came September 11, 2001. The collapse of the World Trade Center collapse destroyed dozens of FDNY pumpers and cut water mains. The fireboats sprang into action. For four days straight, they pumped water out of the Hudson River, feeding the hoses of firefighters trying to extinguish the burning rubble. They proved that whatever the changes to the harbor, there will always be a role for the FDNY's fireboats.

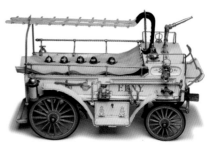

High-pressure hydrant wagon model, 1910s.

northward, leading to the extension of high-pressure water lines to 34th Street. The elevated train tracks were gradually dismantled, and urban train service was now being routed along the new subway lines. After two tragedies involving these modern constructions-the 1912 Equitable Building Fire and a smoky 1915 subway fire which sent nearly 200 people to the hospital-Kenlon realized that regular fire companies were not equipped to handle large disasters. In 1915, he formed the first Rescue Squad, headed by Captain John J. McElligott, giving its men special training and equipment to deal with the new challenges they faced. Rescue Squad No. 1 proved its worth when a subway tunnel under a crowded street collapsed, and its men rescued dozens of trolley passengers and pedestrians who fell into the hole.

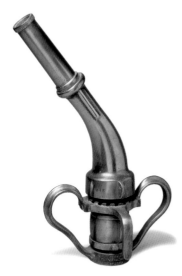

Hand-held nozzle.

*I*n 1917, the United States went to war in Europe, and many firefighters enlisted and performed bravely on the field of battle. Those who remained had to face a new kind of danger: Enemies from overseas tried to help their cause by making attacks on American soil. The Port of New York was the largest embarkation point for troops and war material for Europe, and German agents tried to stem this flow with a campaign of bombs and sabotage. The largest such attack actually came in 1916, when rail cars loaded with dynamite and munitions bound for Europe were detonated in a huge explosion on Black Tom Island (near Ellis Island) probably caused by German infiltrators. The FDNY fought these dangers as well as numerous fires caused by overloaded ships and accidents at shipyards and military docks.

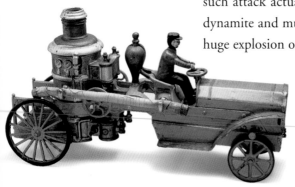

Tractor-driven steam engine model.

Although the FDNY had made huge strides over the previous two decades (and motorized equipment had taken over much of the back-breaking work), its firefighters felt that they were still living in the stone age

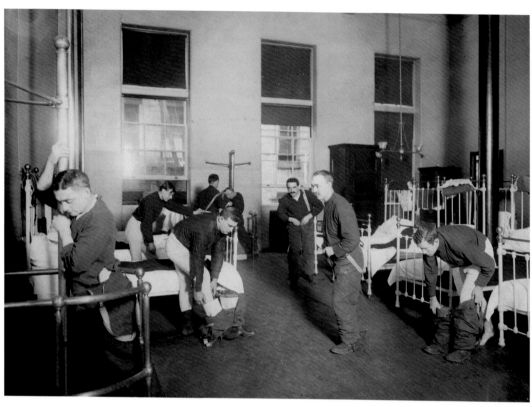

as far as duty hours and pay. Firefighters were on duty 21 hours a day, or 151 hours a week. The old joke was that they could only go home to eat dinner and make babies. To make matters worse, their firefighter's pay averaged only 1500 dollars a year and was losing ground to inflation. In 1917, firefighters had organized the Uniformed Firefighters Association, which the following year became Local 94 of the International Association of Fire Fighters. In 1919, the union won for its men a pay jump to 1900 dollars. Three years later, the UFA convinced the FDNY to replace the old continuous duty with a two platoon system; now the companies were divided into two 12-hour shifts, and the men only had to work a total of 84 hours per week. Over the years, the UFA became an important part of the firefighter's livelihood, fighting for job security, disability benefits, and pensions. Being a firefighter was now not only a public service, it was a good, solid job.

Firemen turn out for an alarm in a typical bunk room, circa 1900.

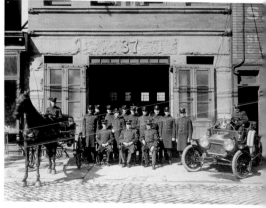

Both horse- and motor-powered, Engine Co. 37 poses outside quarters on Amsterdam Avenue and 126th Street.

BOOM AND BUST

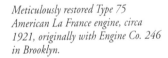

Probationary firefighter badge from the 1930s.

During the 1920s, urban New York City expanded with incredible rapidity into the rural areas of the Bronx, Queens, and Brooklyn. Almost as soon as the ink was dry on contracts for new streets, trolley lines, or subways, developers were on the spot building blocks of row houses, semi-detached homes, and small apartment buildings. Riding an economic boom, thousands of residents of the old tenement districts made the leap across the river into these new neighborhoods, beginning a cycle of ever-outward expansion. As the city grew, so did the demand for water. The expanded Croton reservoir system was now too small, so the city built a second reservoir system a hundred miles to the north in the Catskill Mountains. On Manhattan, meanwhile, skyscraper construction proceeded apace, now spreading even further uptown to the area around 42nd Street and Grand Central Station.

New York City's fire department reacted to these changes with increased professionalism and efficiency. In the once-rural parts of the outer boroughs, the FDNY took over most of the remaining volunteer fire companies and built new firehouses. Between 1920 and 1926, the department purchased an average of 24 new American La France pumpers every year (and also more ladder and hose wagons). Now every firehouse in the city had a motorized engine, greatly increasing the firefighters' range. The city's alarm signals were now routed through central offices, allowing a much more efficient dispatch of fire companies.

Meticulously restored Type 75 American La France engine, circa 1921, originally with Engine Co. 246 in Brooklyn.

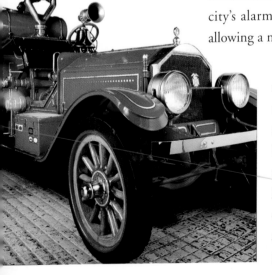

Memories of the Triangle Shirt Waist tragedy were still fresh, and the FDNY met little trouble promoting the cause of fire prevention (although business groups still resisted some safety improvements). Most businesses and residences now used electric light, rather than gas, removing one of the most notorious fire hazards. Factories held regular fire drills, and large commercial structures had to meet requirements for stand-pipes, sprinkler systems, fire doors, ample interior fire stairs, and other fire safety features. Fire

officials knew, however, that it was not just education and construction codes that prevented more large fires from happening during the 1920s, but also plain dumb luck.

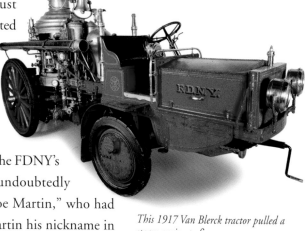

*D*uring these years, the FDNY was still led by Chief John Kenlon, whose foresight and long experience helped guide the department into the modern era. The FDNY's most renowned firefighter, however, was undoubtedly Joseph Martin, better known as "Smoky Joe Martin," who had joined back in 1884. Chief Croker gave Martin his nickname in 1899, when he refused to give ground in the face of a fire's rapidly increasing heat and smoke. After ordering Martin to retreat, Croker introduced him to the assembled press, saying, "Gentlemen, this is Smoky Joe Martin. By the gods, he certainly does love it." That never-give-up quality stayed with Martin through the rest of his career. In 1922, Martin led the charge into a Manhattan warehouse filled with flammable materials; there, a small blaze turned into a four-day conflagration dubbed the "Greenwich Village Volcano." After a series of huge explosions seared Smoky Joe's face, and falling

This 1917 Van Blerck tractor pulled a steam engine to fires.

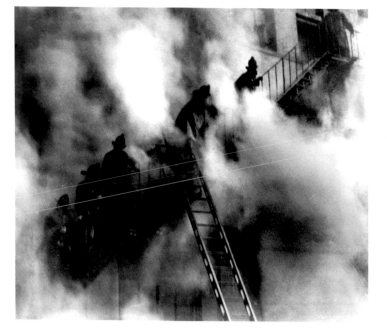

Dietz hand lantern, early 20th century.

Firefighters mount the attack.

debris killed a firefighter reporting to him, doctors wanted Martin to go to the hospital for treatment. He refused and, his head covered with bandages, led the operation from a cot in a funeral parlor across the street. In 1930, Martin's legs gave way at a fire, and this time the doctors won: At age 66, Smoky Joe entered retirement.

That same year, New York City and the nation entered the century's worst economic depression. Millions lost their jobs; families could not pay their rent and were thrown into the street; and breadlines began to stretch the length of city blocks. In city politics, Tammany was back in charge, and under the ebullient but inattentive Mayor Jimmy Walker corruption was rife in nearly every city agency. Meanwhile, the FDNY kept up its aggressive purchasing plans, buying dozens of new engines, ladder trucks, and the John J. Harvey fireboat and continuing to build new firehouses. In 1932, however, after a series of blistering revelations about how Tammany turned city government into its own personal piggy bank, Jimmy Walker was forced to resign. The following year the Tammany candidate was soundly beaten by a relatively unknown reformer named Fiorello LaGuardia, and the political machine began a long, permanent decline. For the next dozen years, the FDNY would develop something of a love-hate relationship with the short but tough new mayor. LaGuardia was a fire buff and deeply committed to the department, but these were also difficult times, and he would demand that the department make sacrifices along with the rest of the city.

Helmet of John McElligot, FDNY Chief of Department from 1932 to 1940.

Type 75 engine rushes to a fire.

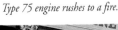

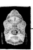

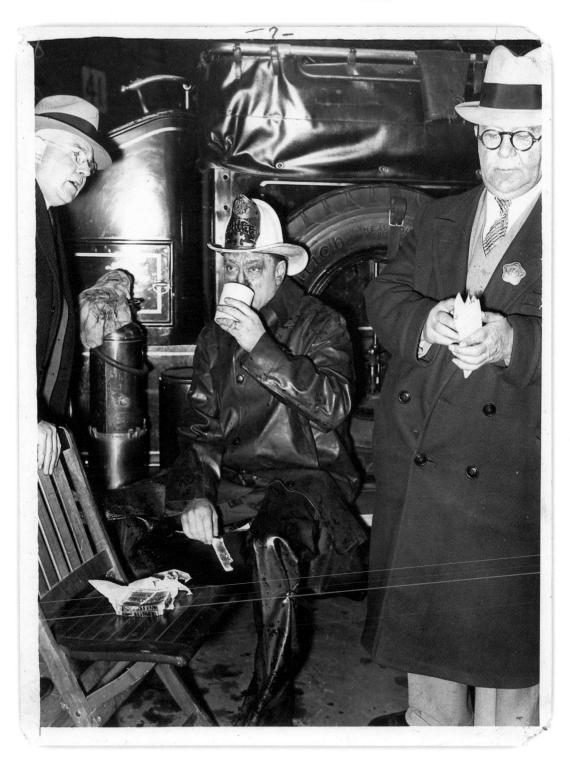

"Taking a blow": Chief John McElligot recovers from a fire with hot coffee and toast.

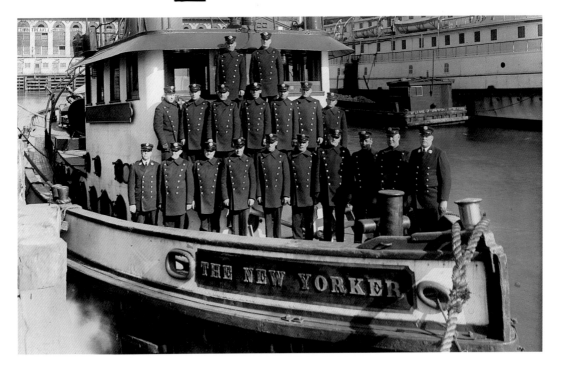

The crew of the fireboat New Yorker *docked at the foot of Beekman Street, early 20th century.*

Pilot's badge for the fireboat New Yorker, *c. 1900.*

*A*fter LaGuardia took office in early 1934, one of his first moves was to swear in John J. McElligott, who had replaced Kenlon as Chief of Department, as Fire Commissioner. This was the first time in city history that one man occupied both jobs simultaneously in the FDNY. McElligott sat behind the commissioner's desk in the Municipal Building, but when a big fire broke out, he slapped on his chief's hat and rushed to the scene. Among the reforms McElligott and LaGuardia instituted was the revision of the bidding process to insure that the department got the actual lowest bid for new equipment and eliminated kick-backs to officials. For the first few years, LaGuardia attempted to cut back on the number of firefighters and reduce their salaries. Some years, the department did not buy any new apparatus at all. But the union blocked the pay cut and manage to save some jobs. The firefighters grumbled about their mayor, yet still admired him for showing up at fires even in the worst weather and during the dead of night. They had made a few sacrifices, but compared to the average Joes on the street, they were lucky. During the Depression, firefighter became one of the most coveted jobs in New York City.

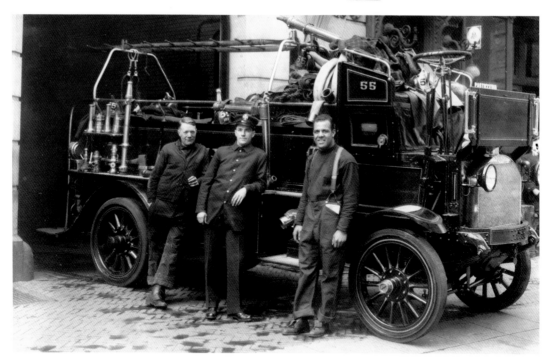

For three centuries, the FDNY had been a white, male preserve. Then in 1919, a man named Wesley Williams decided that he was going to join the force-and on the same terms as whites. He was aided by the city's strict civil service rules, which said that anyone who passed the written and physical tests must be given the job. The day Williams arrived at his post, Manhattan's Engine Company 55, the captain quit, and the rest of the men demanded that the "probie" (probationary firefighter) sleep in the cellar. Williams refused, so the others moved to the cellar. Although Williams was ostracized and frequently goaded to fight, he was tough both mentally and physically (he was a bodybuilder and champion amateur boxer). He met every challenge and confounded his foes by taking, and passing, the tests for advancement. Williams became the FDNY's first black lieutenant, captain, and then battalion chief and insisted in serving in the field, not headquarters.

Hose wagon for Engine Co. 5. The man on the right is Wesley Williams, one of the first African-American firefighters in the FDNY.

Helmet frontpieces used by the FDNY, 1931–1971.

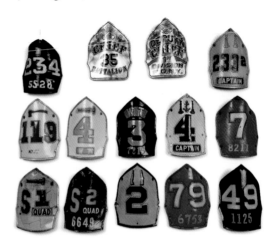

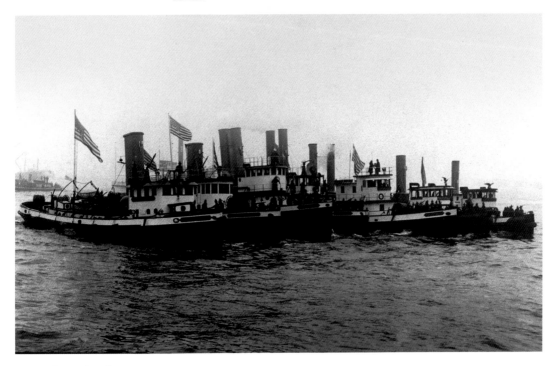

Fireboat fleet, early 20th century.

Engineer's frontpiece from Marine Engine Co. 51, a fireboat, c.1900.

\mathcal{D}uring the 1930s, Williams' example, and the desperation of the times, led dozens more blacks to join the department. Although white firefighters realized that they could not keep blacks out of uniform, the vast majority of them still refused to treat blacks on equal terms. Fire stations had "black beds" set aside for African-Americans, and physical confrontations were common. Those blacks that survived could not let down their guard for a minute and, to show that they were at least equal to whites, made a point of performing perfectly as firefighters. In 1940, this atmosphere of racial tension led Wesley Williams and a group of others to form the Vulcan Society for black firefighters. This vehicle allowed blacks to bring their problems to public attention, although racism continued to be part of the entrenched FDNY culture.

The city economy improved at the end of the 1930s, and the FDNY began aggressively hiring new firefighters. It also changed the old two-platoon, 84-hour workweek to a three-platoon, 50-hour week. The job began to seem less like military service and more like regular employment. Ironically, this occurred just as war broke out in Europe, and most people believed that the United

FIRE MARSHALS

New York City has always been plagued by the malicious setting of fires, with tragic costs to both people and property. In its early years, the FDNY made no organized attempt to either prevent arson or investigate the crime after it happened. Then in 1854, Alfred E. Baker, a reporter for the New York Herald, was struck by the number of "peculiar fires of doubtful origin." Neither the fire department nor the police department were making any effort to find out their cause. He brought his suspicions to the Chief Engineer Alfred Carson, who asked him to investigate the fires and try to catch the arsonists. The department could not pay Baker, so Carson asked the insurance companies to set up a fund to remunerate him. After Baker averted a number of fires and arrested the arsonists, he was awarded the title of Fire Marshal and allowed to wear the red shirt, fire cap and fire coat of a firemen.

Baker performed his most important work during the Civil War, when fires burst out in a number of city hotels and other landmarks. He discovered that most of them were fueled by "Greek fire," a phosphorus-based accelerant that has been used since ancient times. This helped Baker uncover a Confederate plot to terrorize and perhaps burn down New York, which was planned and executed by Confederate secret agents and their Northern "Copperhead" traitor accomplices.

Alfred Baker's solitary crusade eventually became the Bureau of Fire Marshals and then the Bureau of Fire Investigation. Today, New York City's fire marshals must serve first as FDNY fire fighters. If they pass the demanding fire marshal test, they are sent to the Randall's Island fire academy for hundreds of hours of further training. They also take the NYPD's criminal investigation course, because they will become police officers, with the power to carry guns and make arrests. After graduation, they will don the red cap and badge of the fire marshal and fan out into a territory extending from Manhattan's posh hotels to the slums of Brooklyn and the Bronx. Fire marshals have one of the most difficult jobs in the FDNY: catching arsonists and preventing further fires from being set. But as with fire fighters, their reward is unequaled: saving lives.

by Peter Micheels

During World War II, the city's auxiliary firefighters were issued red-painted civil defense helmets.

States would also be drawn into the conflict. LaGuardia argued that firefighters were essential workers and (like the 19th century volunteer department) should be exempt from serving in the armed forces. Realizing the possibility of air raids and other attacks, however, LaGuardia and Patrick Walsh, his new Fire Commissioner/Chief of Department, established the Fire Department Auxiliary Force. Made of male volunteers age 18 to 55, the auxiliaries received 60 hours of training and drilled every Saturday; by December 7, 1941 this force numbered over 31,000 members.

*T*he entry of the United States into World War II justified LaGuardia and Walsh's preparations. New York City again became the nation's main embarkation point for soldiers and war material heading to Europe and Africa. While the total number of fires dropped due to the watchfulness of the auxiliaries, the waterfront became impossibly busy. Dock and ship fires, some caused by sabotage, were common. In early 1942, the luxury

Fireboats attack a smoky warehouse fire, Red Hook, Brooklyn, 1955.

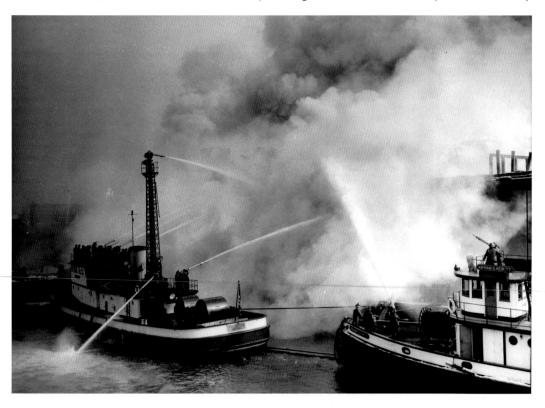

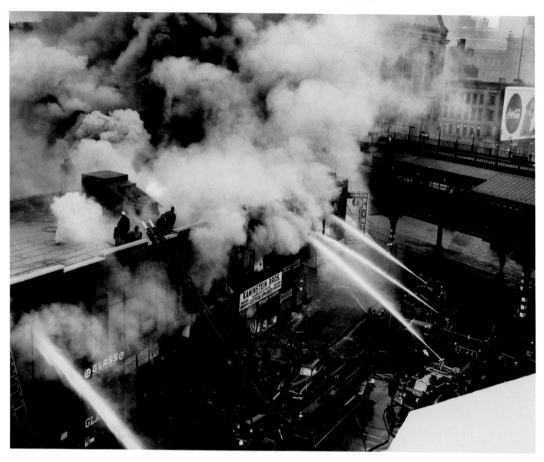

Multiple alarm fire at 3rd Avenue and 10th Street, Manhattan, 1949.

liner Normandie, which was being turned into a troopship, caught fire with 2,700 soldiers and workmen aboard. Five alarms were transmitted, and three fireboats and 44 pieces of land apparatus rushed to the Hudson River docks. Firefighters fought the blaze for over 12 hours, rescuing hundreds of people. Over the next three years, the FDNY fought hundreds of shipboard blazes, many on boats filled with explosives, and provided crucial assistance to the war effort.

The Grace Line pier fire, 1947.

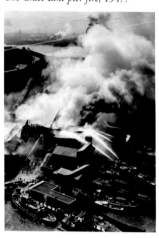

Patrick Walsh, who had joined the FDNY back in 1901, practically begged his men to stay home and protect the home front. Nevertheless, almost 2,000 firefighters felt their duty was elsewhere and enlisted to fight overseas. City firehouses became woefully understaffed at a time when many feared an attack like the air raids on London that caused thousands of fires a night.

Faced with this urgency, Walsh abolished the 50-hour, three-platoon system and decreed a return to the two platoon and 84 hours a week routine. Seconding him, LaGuardia decreed that the regular cost-of-living bonus would only be given to those who worked the extra hours. The firefighters were furious. For the first time in the paid department's history, a chief of department faced a massive rebellion in the ranks. The union sued to block this order, and a Bronx firefighter even wrote to the newspapers criticizing his chief. The firefighter was sent to the equivalent of

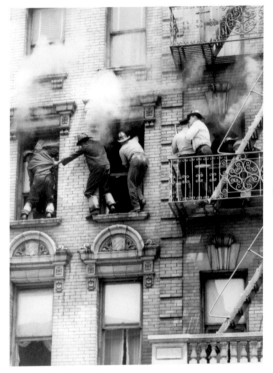

F.F. Stan Hirshfeld of Ladder 40 clambers across windowsills to rescue a four-year-old boy, Harlem, 1952.

Siberia (Staten Island), and a judge decreed that Walsh's orders were justified by the wartime emergency. Walsh's men grumbled privately but went back to work for the old 84-hour weeks. It was not until 1947 that the firefighters saw a return to better hours.

POST-WAR GROWTH

After the end of World War II, New York City was the financial, industrial, and cultural capital of the most powerful nation on Earth. The majority of the country's largest corporations made their headquarters here; new steel and glass skyscrapers rose in Lower Manhattan and along the corridors of Midtown; and fittingly, a new organization called the United Nations decided to make New York City its home.

Although New York was nominally governed by its elected officials, the prime architect of the postwar city was a brash, visionary public servant named Robert Moses. Placing the United Nations building in Manhattan overlooking the East River had been his idea. So had been building the FDR Drive that ran beneath the U.N., as well as the West Side Highway, the Brooklyn-Queens Expressway, the Cross-Bronx Expressway, the Brooklyn-Battery Tunnel, and on and on. Robert Moses (who never learned to drive)

SAVING LIVES

Lieutenant Jack Fanning, Ladder 26, Manhattan:*

It's an incredible feeling, knowing that a person would have died it hadn't been for you. At another fire a lot of people were carrying on in the hallway, saying that somebody was in the apartment. You can sometimes tell that they're not kidding and there really is somebody in there, and that's what happened one night on Fulton Avenue in the Bronx. When we got up to the site, the fire was in the kitchen. My officer and I passed the fire and got into the rear of the apartment. We were searching the rooms and it was getting worse; the fire was extending in our direction and back to the entrance of the apartment. But the people in the hall were really serious about somebody being in this apartment, and we just had a feeling that they were right. We searched the two bedrooms, and we took a shellacking in there. We didn't have masks on and we came up short of air. We were met by one of the guys who came in off the fire escape and continued to search; he found a girl in the bathtub-they say that people go to a source of water in a fire. In any rate, he found her and dragged her out. We just dashed out behind him.

When he got out to the hall, he collapsed, so I went to work on the woman with mouth-to-mouth resuscitation. There was no pulse, no breathing—nothing. She was gone, but we worked on her out in the hallway for a good ten minutes. I could hear the other guys saying that she was gone. Then all of a sudden she gurgled, so we knew the mouth-to-mouth was having some kind of an effect. She came back, and it was only because we stayed with the mouth-to-mouth over that period of time instead of giving up on her and handing her to the ambulance guys. I just stayed with simple mouth-to-mouth while one of the other guys was doing cardiac pressure. Otherwise that girl would have been dead. Knowing that was an incredible feeling. That was satisfaction at its best. I felt like I'd really arrived. I wanted to be a fireman and this is what being a fireman is about. This is what comes of it. Tragedy comes of it sometimes, but so do the highs. That was one of the biggest highs that I've had.

From "Braving the Flames" by Peter A. Micheels, New York, 1989, 2002

* *Battalion Chief Fanning, Chief of Haz-Mat Operations, lost his life on September 11, 2001.*

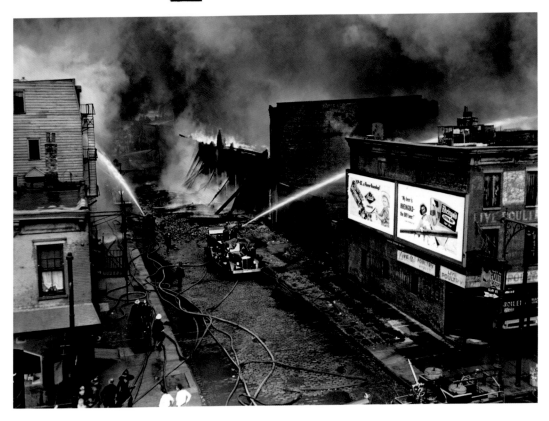

The great Greenpoint, Brooklyn fire of June 30, 1952.

believed in the automobile, in a great network of concrete highways that would link New York City with the suburbs where most people would live. He also hated tenements, narrow streets, and anything that reminded him of the city's often-shabby past; he had no qualms about evicting thousands of tenement dwellers to make way for his highways. To replace their homes, Moses built a series of towering brick apartment complexes across the city, each surrounded by grass and playground. Moses did not foresee that these would become the sky-rise slums known as the "projects." For the city and for the FDNY, Robert Moses's creative energy would be both a boon and a curse, causing scars that took decades to heal.

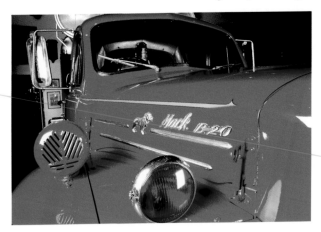

1959 Mack searchlight truck with electric siren.

SMOKE

Lieutenant Jack Fanning, Ladder 26, Manhattan:

I've been in ladder trucks for most of my time on the job. Our big job is to search the fire apartment and all others that are burning. When I first began doing truck work, taking one step into an apartment that was on fire was taking a big step. It's very scary. You're in there searching without a line and you have zero visibility. All you're feeling on the exposed parts of you is heat, and you can't move around as easily as you would normally. A table or a chair can become your worst enemy. Your mask gets hooked on it. Something as simple as a small end table could take on nightmarish proportions. Maybe all you want to do is back down the hallway, but you get hung up on this table. It becomes an adventure in there. If you feel a chrome blade on a chair, you figure you're in the kitchen. You feel tile on the floor, you're in the bathroom. You swing your tool and you hear a clank, you say, "Oh, that's the bathtub; I'm in the bathroom now. All right. I'll line myself up with the bathtub and there should be a small window on that wall giving a certain amount of vent up there." You step into another room and work your way along the walls, always trying to remember that this is your way out when the time comes. What happens many times is you're searching along a wall and now you want to get out, and all of a sudden you find yourself in a room you haven't gone into yet—and you're totally disoriented. You go for a window. For a guy first doing it, this could be terrifying. You're in a burning apartment. You're alone and if you want to get out at this moment you can't find your way. You're just hoping that the guys are bringing the line up and this place isn't lighting up around you. But time and experience work in your behalf.

Two firefighters operating a hose line.

From "Braving the Flames"
by Peter A. Micheels,
New York, 1989, 2002

As the war effort winded down, thousands of veterans returned home to New York City and joined the fire department. From 1947 on, the lot of the firefighter improved rapidly. Hours shrunk, pay increased, and the FDNY finally had the money to purchase large amounts of new equipment. Many of the new engines now had booster pumps, and the ladder trucks began to carry new metal aerial ladders, which were longer, stronger, and more maneuverable than the wooden version. Firefighters also began to reap the benefits of many innovations developed for the military. The most important was a lightweight, self-contained breathing apparatus, originally built for pilots, that could now be carried into fire situations.

From the late 1940s on, firefighters' lives also improved beyond the firehouse. Many reaped the benefits of the GI Bill and were now attending college part-time (while among the old-timers it was rare to find one with a college education). Robert Moses's highways had opened up new suburbs in Westchester, New Jersey, and particularly Long Island. In huge developments like

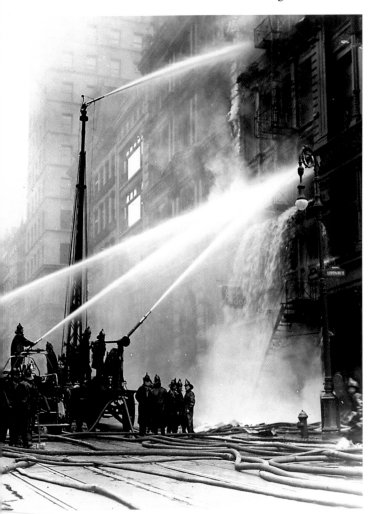

Water tower in action, Lower Manhattan.

Levittown, homes were cheap and terms were easy. Many firefighters became suburban homeowners and now commuted back to their jobs in the city. Although this was a violation of a city law reserving FDNY jobs for city residents, most higher-ups looked the other way-they were moving to the suburbs as well.

Back in the firehouses, however, the familiar routines remained largely unchanged: maintaining the apparatus, cleaning house, and attending the communal meals. FDNY culture was strong, and the firefighters remained a tightly-knit brotherhood.

For the FDNY, one drawback of New York City's vast array of new construction projects was that they made fighting fires a much more complex and potentially dangerous task. In May of 1949, a truck loaded with chemicals illegally entered the Holland Tunnel heading to New Jersey. The chemicals caught fire and exploded, causing clouds of toxic smoke to billow through the tunnel. Four rescue companies sped to the scene, where over 75 firefighters and civilians were injured by smoke, and one battalion chief died. The new breathing apparatus undoubtedly saved many lives and

From top: Kelly Tool, Halligan, and Claw Tool, all designed for forcible entry. The Halligan was designed by Chief Halligan of the FDNY in the late 1940s to have the combined features of the two other tools. It is particularly useful for breaking locks and forcing open doors.

The "Harlem Spectacular": fire on West 132nd Street, March 4, 1957.

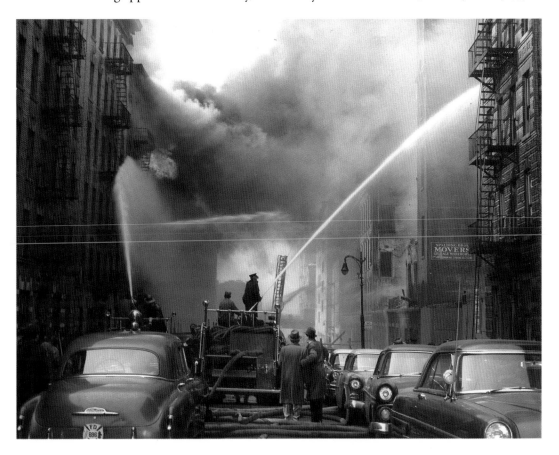

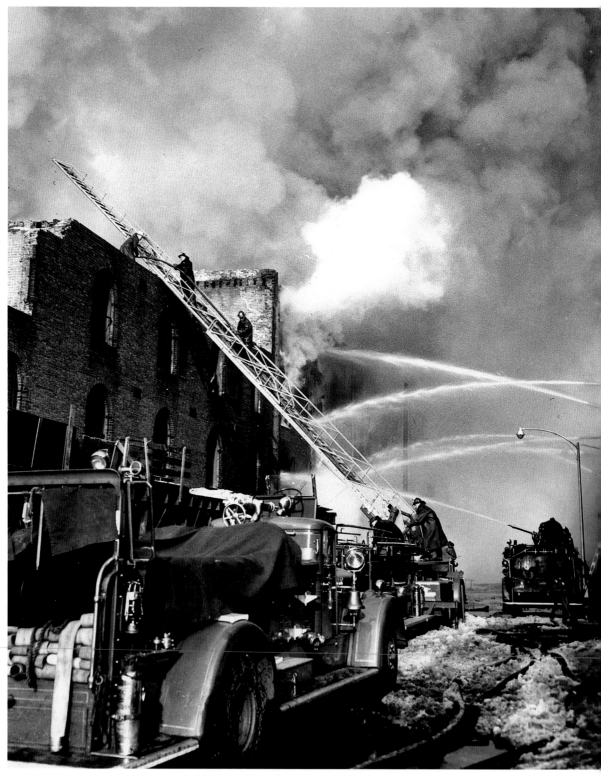

Red Hook, Brooklyn multiple-alarm warehouse fire, 1955.

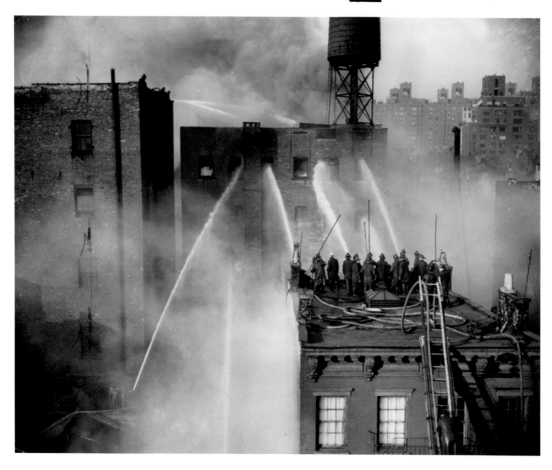

was a great help in combating the fires. It took months to completely repair the tunnel, while the FDNY used the fire's lessons to improve their tactics in fighting chemical fires. The city had been relatively lucky with the Holland Tunnel fire. If a truly big disaster occurred, however, would the FDNY have adequate resources and an effective strategy to fight it? This question took on added urgency when the world learned that the Soviet Union had the atom bomb. The department began to plan for an atom bomb attack, which would cause vast fires and radioactive fallout, and reactivated its auxiliary force. This work culminated in a 1953 mock attack drill that involved 23,000 firefighters and apparatus from as far away as Albany. Political attentions strayed, however, and the FDNY never received funds to purchase most of the needed equipment.

The fire wins: firefighters forced into a defensive position.

"Y" connection for dividing a hose line.

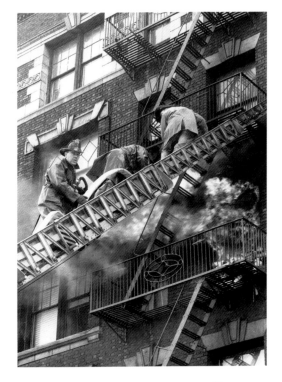

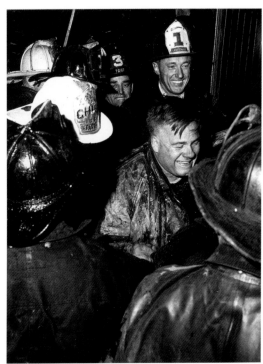

Top Left: *Firefighters from Engine Co. 58 operating an aerial ladder at a Harlem fire, 1950s.*

Top Right: *Last man out: FF. Harry Fay of Engine Co. 54 is the last of seven trapped firefighters removed from a two-alarm fire, 6th Avenue and 46th Street, Manhattan, 1966.*

The 1950s was a decade of general optimism for the city and its fire department. Below the surface, however, there was trouble brewing: The number of fires, and particularly deadly fires, was increasing every year. In the slum districts of Upper Manhattan, the South Bronx, and Brooklyn, old tenement buildings were regularly catching fire, often with disastrous consequences for their residents. Firefighters could not point to a single cause-arson, carelessness, accidents, etc.-but tried new strategies to keep the fires under control. One of them was the establishment in 1955 of squad units in high-fire districts; these units rushed to large fires to provide more manpower to the regular companies. Nevertheless, the number of fires continued to rise every year. Meanwhile, in Lower Manhattan the most fire-prone area was a seedy manufacturing district that occupied a large area (roughly from City Hall to Houston Street) between the Financial District and the skyscrapers of Midtown. After too many firefighter fatalities there, Fire Commissioner Edward Cavanagh coined a name for this neighborhood: "Hell's Hundred Acres."

PRANKS

Lieutenant John Vigiano, Rescue 2, Brooklyn:
At one time I worked with a buddy of mine, Bill Trotta. He and I were nicknamed the Katzenjammer Kids. We were so bad together they wouldn't let us work together. We were constantly pulling pranks. This one particular night we had rigged up some firecrackers in with the burners so if somebody would turn on the stove, seconds later the firecrackers would go off. We had this one lieutenant in 290 Engine who was very straight. He was the type of man who if he walked into a room naked you'd probably salute him, because he just had that aura about him as an officer. Every night at ten o'clock he brewed a cup of tea. He went to the teakettle, filled it up, and put it on the stove; it was like a ritual. We had set up our firecracker trick earlier, but I forgot I still had one in this burner, and here comes the lieutenant. He fills up his pot. We were watching TV or shooting pool—God only knows what we were doing. I looked at my buddy and he looked at me and I said, "Oh, no!" The lieutenant put the teapot over the stove, turns the jet on, turns his back to the stove, and the thing lets go. Well, it wasn't just a firecracker; it was actually a cherry bomb. The pot went about eight inches off the stove. When that thing blew up I ran, and I just kept running. He turned around and he was beside himself. He takes the pot and runs into the truck office and he's standing there yelling at Lieutenant Matty Farrell, and Farrell is looking up. Then the lieutenant asked, "Do you see what they did? Do you see what they did?" He's shaking the pot and the water is going all over. Farrell, who is very quick, says, "No, what did they do?" The lieutenant says, "Look what they did to my teapot!" And then I guess he realized how ridiculous it was. And he said, "You're just as bad as they are," and threw the pot down and slammed into his office. Farrell started laughing, and he came into the bunk room. He asked, "Where are you?" I was hiding behind a locker, and he goes, "Just get a new teapot by tomorrow morning." He had that knack of never losing his cool. He was great. What a boss.

From "Braving the Flames" by
Peter A. Micheels, New York, 1989, 2002

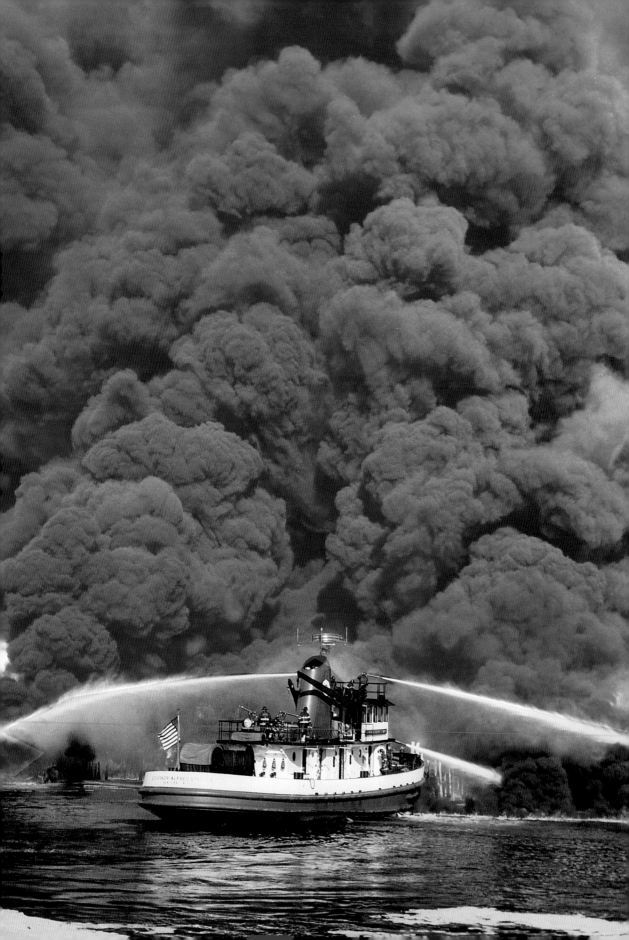

For Manhattan's firefighters, Hell's Hundred Acres was the most hazardous district on the island. Its decaying 19th century loft buildings housed sweatshops, printing plants, small factories, warehouses, and the like. Nearly every one of those buildings was a firetrap, with nailed-shut doors, no fire escapes, and no sprinkler systems. They burned easily, collapsed quickly, and were often stuffed with dangerous chemicals and highly flammable materials like old rags, bales of paper, and scraps of celluloid. Firefighters faced constant dangers from poisonous fumes, explosions, and even drowning–floors often collapsed into cellars and sub-cellars that had filled with water from the firemen's hoses. It was not until the late 1960s that fires

Life ring from the fireboat Gaynor.

finally began to decline there, due to more stringent building codes, better enforcement, and the shift of light manufacturing out of the city. (Today this area has become the neighborhoods of Soho and Tribeca, two of the most expensive districts in the entire city.)

To add to the danger, too many of the firefighters working in these fire districts were little more than raw recruits. Back in the late 1930s, Mayor LaGuardia had added thousands of firefighters to the force; now their 20 years were up, and they were filing their retirement papers. The firehouses were emptying out, while the probationary firefighters coming in to fill the posts had literally no training or experience. Up to this point, it had been FDNY practice for probies to first go to their firehouses for hands-on training from the old-timers and then report to Probationary Firemen's School on East 68th Street in Manhattan. Now the department decided that, due to the dangers and new complexity of firefighting, probies should go to school first and then get their assignments. In 1963, the FDNY opened its new Bureau of Training facility on Welfare Island (now Roosevelt Island), where probies would undergo an intensive nine-week training.

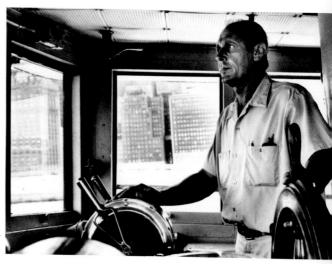

At the helm: Marine Pilot Aldo Anderson steers a fireboat.

Left: *Mill Basin oil fire, May 10, 1962.*

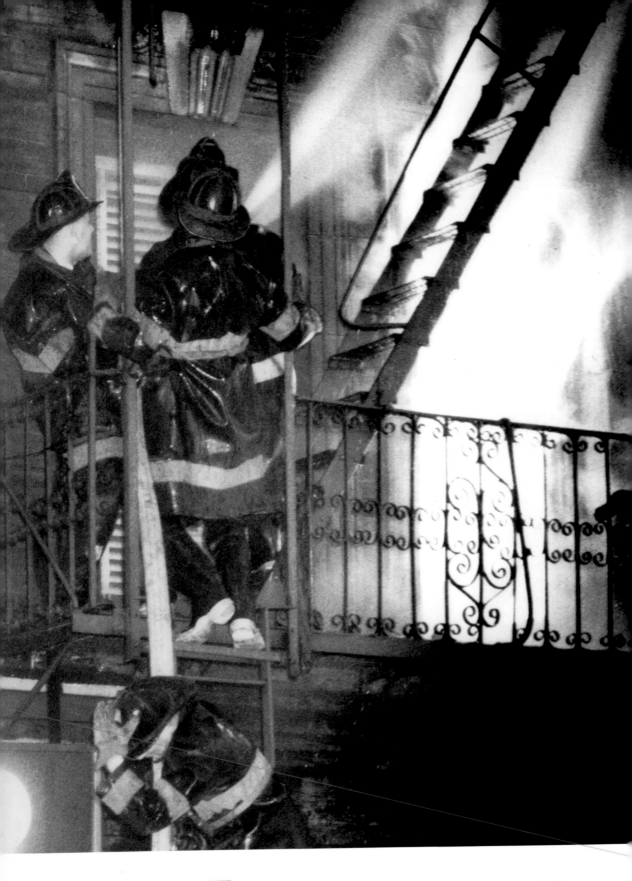

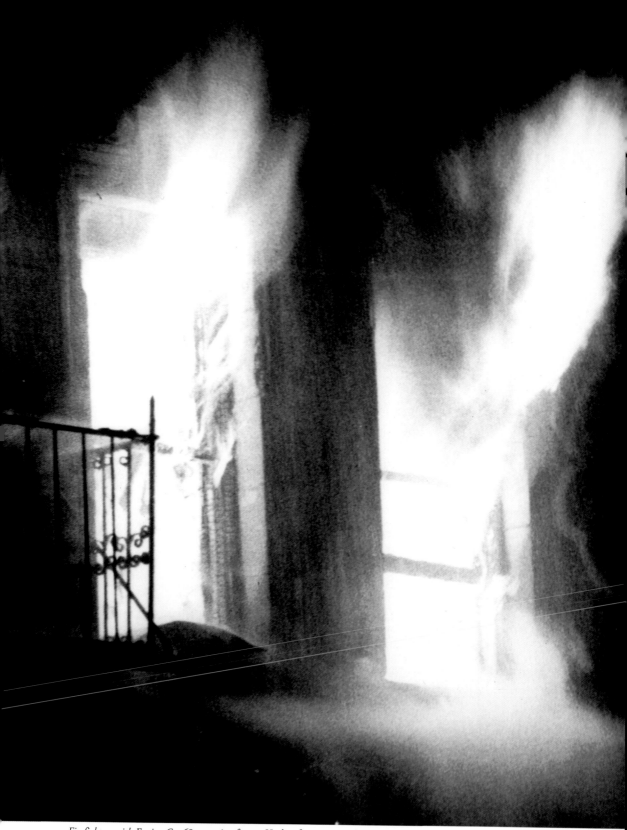

Firefighters with Engine Co. 69 operating from a Harlem fire escape, early 1960s.

The mid-1960s brought a number of important technological improvements to the FDNY's firefighting capability. These included rotary power saws for cutting through roofs and ceilings and tower ladders capable of reliably delivering heavy water streams to the upper floors of buildings. All the new apparatus was diesel-powered rather than gas, and in 1968 the first fire engines with automatic transmissions were delivered. To combat fires fueled by chemicals and other accelerants, the FDNY now had high expansion foam which could cool and extinguish enough of the fire to allow hoses to be used. The most impressive piece of new equipment was a "land fireboat" called the Superpumper, which was the most powerful land-based firefighting apparatus ever built. The size of a semi truck, it could pump an astonishing 8,800 gallons of water on fires. To speed its deployment, special Superpumper satellite rigs were stationed around the city. Unfortunately, the Superpumper system was too complex and expensive, and the engine too large for many city streets, and in 1982 it was discontinued from fire service.

In 1965, the FDNY celebrated its centennial with a huge parade in which many of its 13,186 firefighters marched. The next year, Mayor Lindsay made history by appointing Robert Lowery, a 25-year veteran and a past president of the Vulcan Society, as the city's first black fire commissioner. A few months later, the FDNY was struck by its worst tragedy since the founding of the paid department. A fire that began in a brownstone on West 22nd Street spread to a commercial building on 23rd Street. Firefighters from Engine 18 and Ladder 7 attacked the blaze from the back via the premises of the Wonder Drug & Cosmetics store on 23rd Street. They did not know that the basement below them was an inferno, and without warning the floor collapsed. A fireman from Engine 18 rushed inside yelling "Eighteen! Eighteen!" into the smoke and flames, but nobody answered. Twelve firefighters died that day, including a deputy chief and a battalion chief, and over a dozen more were injured. For firefighters who were on the force that day, the 23rd Street tragedy remains fresh in their memories.

Right: *Nighttime blaze.*

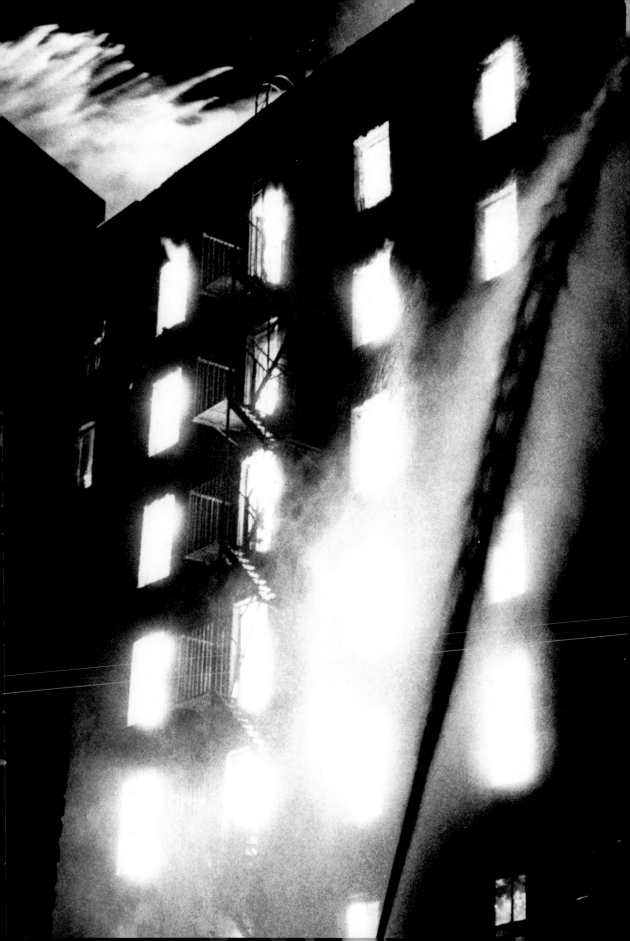

The October 17, 1966
23rd Street Fire

Her eyes were deep in her face and they said nothing. Black smears ran across her cheeks. She stood there with her hands in the pockets of a brown corduroy car coat. The water from the hoses ran under a pile of wood with nails sticking from them and the water came up against her feet and darkened the flat brown shoes.

She stared at the sign which said "Wonder" and then underneath it was "Dru" The "g" and the "s" had been seared out by the flames. She stared at the sign and at the firemen climbing over the debris in the entranceway and she waited for one of them to come out and tell her that her husband, James Galanaugh, was all right.

Her husband was inside the drugstore, down in the basement, and he was dead in a pile of cinderblocks and tin and wood which had burned over him, and the firemen were digging and trying to get at his body so they could drape it in a gray blanket and carry it outside.

"Maybe he could be alive," Mrs. Galanaugh said.

The firemen standing with her looked down at the water running against their boots.

A big guy in a black raincoat came up to speak to her. He was Gerry Ryan, then the head of the Uniformed Firefighters Association.

"Why don't you go someplace and rest? " he said quietly. "We'll come the minute we know something."

"I want to be with him," she said. "Maybe he'll be all right."

Her hand came out of her coat and she ran it through her uncombed reddish blonde hair.

"My father dies on this job," she said. "My father first. And now my husband. Is my husband dead, too?"

Gerry Ryan stood in front of her and his seamed face broke and he wept while the woman in front of him stood and looked at the place where she thought maybe they would find her husband alive.

Firemen were crowded at the entrance to the drugstore, forming an alley between the store and a red-and-white ambulance which had been backed to the curb.

Then there was a murmur and the firemen were taking off their helmets and three of them came up onto the top of the debris in the doorway. The three were bent over and their hands were holding the front end of a wire basket that held the body of a fireman who was dead and wrapped in a gray blanket.

They came down the pile of debris and the ones holding the back of the basket came after them and they walked through this alley of smeared faces that were wet with tears and they put the body into the ambulance.

And a chaplain, Canon E.J. Downes, his dirty hands clasped in front of him, followed the basket and said, softly, "Under God's gracious mercy and protection we commit you."

A heavy man who looked like her brother, and a fireman with his helmet off in respect, put their hands on Mrs. Galanaugh's back. They guided her away from the water and the hoses and the store her husband died in. Her feet dragged as she moved. She did not cry. She looked straight ahead and around her were the sounds of the business her father and her husband were in.

"Tommy Reilly went right in, he wasn't in there a minute and he was gone."

"How many is that now, six or seven out?"

"Al Hay was next door. He felt this shock wave and he got thrown against the wall. He knew it was bad then."

"Where's the chief? We're not supposed to do anything until the chief tells us."

They guided her across the street, to the sidewalk in front of Madison Square Park, and Mrs. James Galanaugh walked under the trees in the bright fall sunlight and everybody looked at her and nobody spoke while she passed.

She had lost her husband fighting fire in this city. And there were eleven others who had died in this fire on Twenty-Third Street. Twelve dead firemen. Twelve widows.

Gerry Ryan stood in the middle of the street. He closed his eyes. "There are fifty-one children involved in this," he said. "Fifty-one children." Somebody standing next to him started to throw up.

By Jimmy Breslin,
New York World Journal Tribune

WARTIME

*T*he statistics tell a story: Nearly every year since the 1950s, the number of alarms, false alarms, and fire-related deaths increased. In 1951, there had been 44,040 fires; 16 years later that number had jumped nearly three-fold to 127,828 fires. And a frightening number of those fires occurred in a relatively small area of the city, mainly the older slum neighborhoods of Upper Manhattan, the Bronx, and Brooklyn. Beginning in the 1930s, the middle class residents had moved from these areas, impelled both by better residential opportunities elsewhere and by massive Robert Moses construction schemes that carved up the neighborhoods. Into the tenements moved poor blacks and Latinos, who due to the lack of education and racism had very

Onlookers at a Little Italy fire.

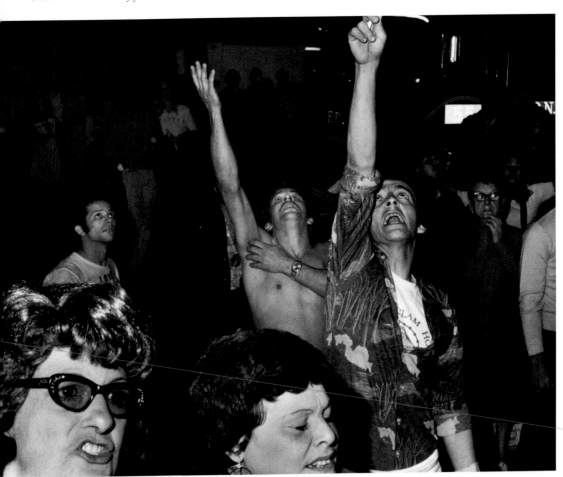

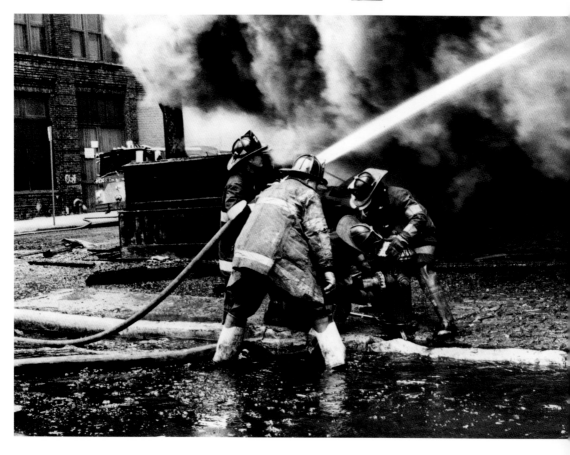

On the front lines of a war.

limited chance for advancement. After World War II and the opening of the suburbs, middle class flight increased dramatically, while Puerto Ricans and Southern blacks poured into the city looking for better lives. Instead, they found a dead end in the city slums, where their resentment grew.

By the mid-1960s, this despair had given way to violence. Very little of it was aimed at any logical target. People burned up their own neighborhoods rather than the neighborhoods of their perceived oppressors. Kids and fire bugs set fires for kicks; squatters in vacant buildings started bonfires to keep warm; spurned lovers threw Molotov cocktails into the stairwell of their ex's building; absentee landlords hired arsonists when they realized that their buildings were worth more for their insurance than whole. Every night, fires lit up the sky, particularly across the South Bronx and Brooklyn.

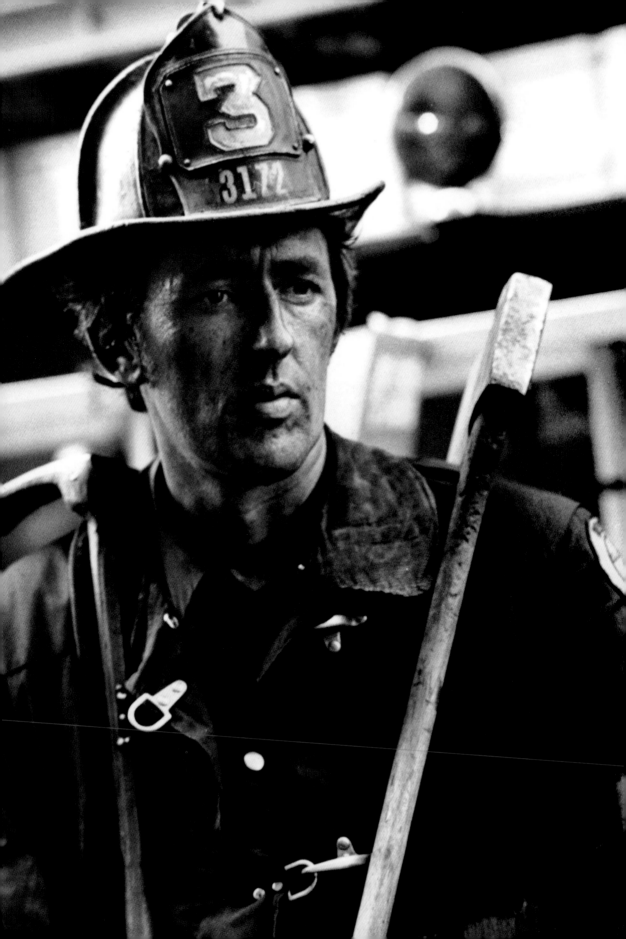

FIRST RUN

Captain George Eysser, Ladder 6, Manhattan:

We were sitting on the grass having our lunch at probie (probationary fire fighter) school on Welfare Island when we saw the Bellevue Hospital Disaster Unit going up the East River Drive. We knew something had happened. The instructor said, "Throw away your lunches. We are going." They loaded us on seven pumpers and we went in a convoy to the neighborhood where I lived in Upper Manhattan. What had occurred was a boiler explosion in the telephone company building at 213th Street and Broadway. This was my first real disaster.

There was a boiler room in the basement, and adjoining the boiler room was a lunchroom. They'd had a problem with the safety valves on the boiler. And the pressure had just kept building up and building up until the boiler blew. The natural tendency was for the boiler to rise. It went up, hit the concrete ceiling, came back down, and rolled like a giant steamroller through the partition and into the lunchroom where over a hundred women employees were eating. It didn't stop until it hit the foundation wall on the other side. It killed eighteen of the women.

We went down into the basement to search for survivors and victims. It was filled with water and the water was red with blood. It was like a wine vat. It was unbelievable. We went up to the first floor to a desk that was right over where the boiler had the hit the ceiling-it had come through the floor a little bit. There was a young woman who had evidently been pinned in her seat. She was directly above the spot where the boiler had hit. She was dead. Her guts were all in her lap.

An off-duty fireman from the neighborhood-not a good friend of mine then, but I got to know him much better later on-came to see if his fiancee, who worked there, was all right. He wound up identifying her body. That day I said to myself, "If this is for openers, I am going to have a very interesting twenty years."

From "Braving the Flames" by
Micheels, Peter A. New York, 1989, 2002

Left: *Firefighter Jack Duggan of Rescue Co.3 carries an ax and a Halligan tool on his shoulders.*

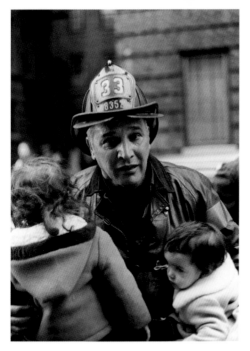

Above: Firefighters' greatest thrill: rescuing children.

Right: Searching for a victim at a Brooklyn fire, 1976.

To stem this inferno, some fire companies were making an astonishing 7,000 or 8,000 runs per year to a record number of fires (in 2001, the busiest engine company made 5,020 runs). Firefighters catnapped on their engines, because it was a waste of effort to climb the stairs to their beds. To make matters worse, people made a sport of pulling the handle on the alarm boxes. These diversions caused loss of life at real fires, while accidents on runs to false alarms caused many injuries and at least one firefighter death. And as they raced through the streets, the firefighters had to keep a sharp eye on the surrounding buildings, because they never knew when a brick, bottle, or Molotov cocktail might come hurtling down on them. For decades, their engines' crew cabs had been open for better visibility, but then firefighters started getting hit by those bricks. The repair shop quickly added plywood or metal covers to the cabs and fireproof tarps over the hose beds. The firefighters were now seen as the enemy, even though they were trying to keep the neighborhood from burning down.

*T*his plague of fires caused the FDNY to alter its strategy in high-fire areas. Less active companies nearby were asked to share the workload of the busiest fire companies. The squad units were one by one disbanded and converted into full-fledged companies. And tactical control units were formed to attack blazes during the peak fire hours from three p.m. to midnight. Alarm boxes sending the most false alarms were designated "discretionary response boxes," meaning that now the battalion chief at least did not have to go until he received confirmation of a fire. In 1970, the city's 911 system finally was improved to allow fire reports to be automatically transferred to FDNY dispatchers. The other challenge was fighting fires during periods of civil unrest, because riots could break out at any time. The department established staging areas close to trouble spots, so apparatus could be rushed (often in convoys for protection) to fires in the shortest period of time.

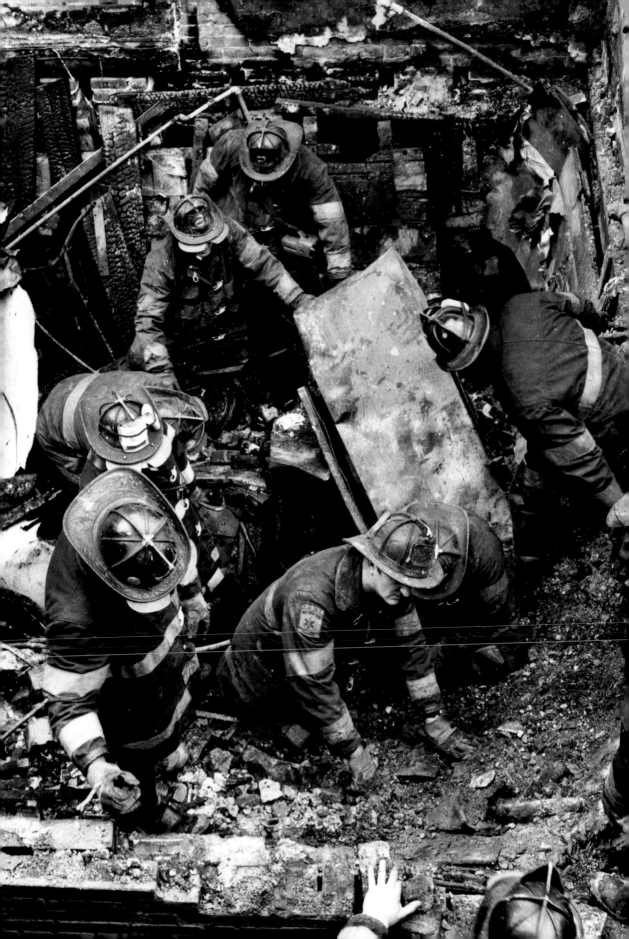

In the early 1970s, the FDNY was fighting an average of over 350 fires a day, a record that still stands. The department desperately needed more equipment and more men, but instead Mayor Lindsay warned of a hiring freeze and possible layoffs. Due to middle class flight and the loss of many industries, the city's tax base had shrunk drastically, and now its leaders were slowly realizing a bleak reality: The city was broke. Pleas of poverty did not impress most firefighters, however. They were tired and frustrated and overworked. They laid their lives on the line every day, while politicians, journalists, students, and intellectuals yammered on about society's blame for the riots, crime, and fires. The firefighters' view was a stark black and white-the criminals and arsonists must be stopped and punished-and they wanted somebody to back them up and recognize their sacrifices. To begin with, they wanted more money.

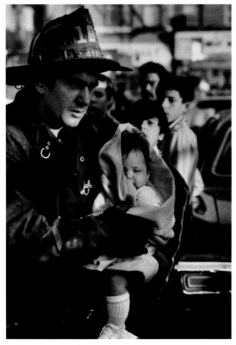

Safe in his arms: the youngest victim.

*I*n 1973, the union demanded a raise of $2,000 to the firefighters' salary, which ranged from $11,000 to about $14,000. Mayor Lindsay offered half that, but UFA President Richard Vizzini said that either they got it all or they would strike. After negotiations broke down, Vizzini mailed ballots to his members asking them to vote on the strike issue. He announced that the vote was for a strike, and on November 6th firefighters for the first time walked off their jobs to join picket lines. Although many disagreed with the strike, they did not want to split the bonds of brotherhood they shared with other firefighters. The firehouses were manned by probies, officers, and non-striking firefighters. As a few fires broke out across the city, Vizzini appeared in a Manhattan courtroom, where a judge told him that the union was in violation of the Taylor Law

Even chaplains had helmets: this leather example made by Cairns Brothers dates from the middle of the 20th century.

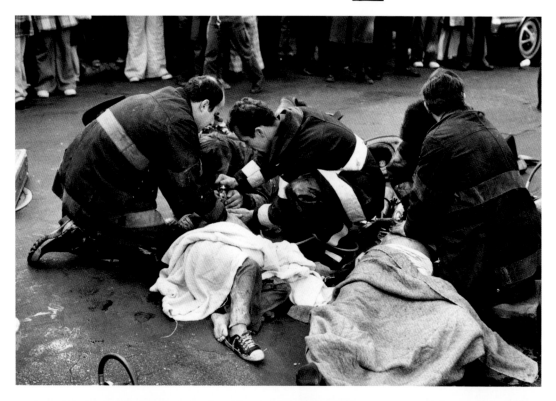

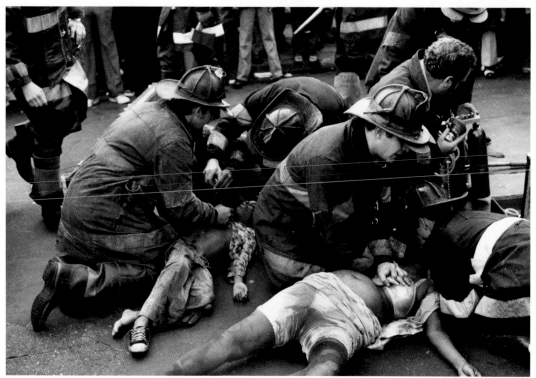

Top & Bottom: *Using the breath of life to save lives.*

forbidding strikes by public employees. If the men did not go back to work, the union would be fined one million dollars a day. Five hours after the strike began, the firefighters returned to work. Days later it was revealed that the majority of firefighters had voted against the strike. Vizzini had lied about the vote to save his reputation. The whole strike had turned into a fiasco and was a further blow to the firefighters' morale.

The situation could not get worse, but it did. When Mayor Abraham Beame took office in 1974, he discovered that the city's coffers were empty. He quickly began laying off city workers and ordered a hiring freeze for the FDNY. This was just the beginning. In December of that year, Beame closed eight engine companies; the following July he shuttered 26 more companies, severely reduced the marine division, and axed almost 1,700 firefighters. Numerous civic groups and neighborhoods protested; in one case, the neighbors held their fire company willing hostages in the firehouse and managed to avert the closure. But most people realized that Beame had no choice: The city faced its most dire fiscal crisis since the Depression, and no department was immune. In 1976, the city's worst year ever for fires, the FDNY fought them with only 10,662 firefighters, down from 14,325 in 1970.

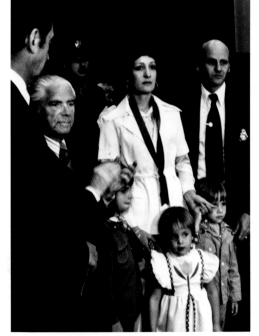

Recognizing bravery: Mayor Abraham Beame gives a medal to a firefighter's widow, 1976.

Right: Tower ladder against the flames.

After Ed Koch became mayor in early 1978, the city's money woes began to abate. During his administration, all the laid-off firefighters who wanted their jobs back returned to work. Under Augustus Beekman, the city's second black fire commissioner, the FDNY now had the money to buy much-needed apparatus and the backing to find new ways to cut back on the number of fires. In neighborhoods like the South Bronx there were few buildings left to burn; once-thriving communities now looked like ghost towns, with rubble-strewn lots and hollow shells of tenement buildings. In the remaining high-risk areas, dozens of red-capped

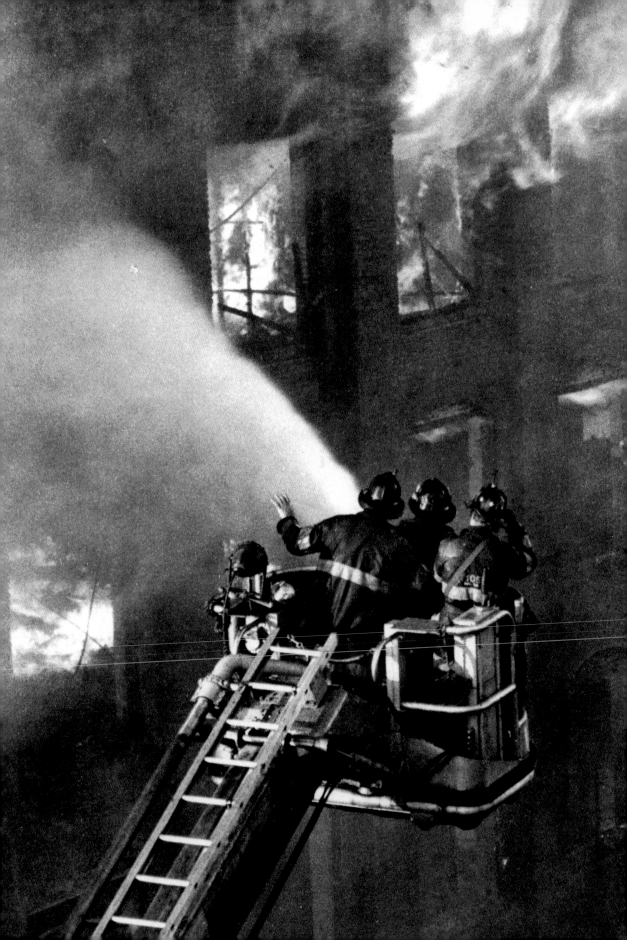

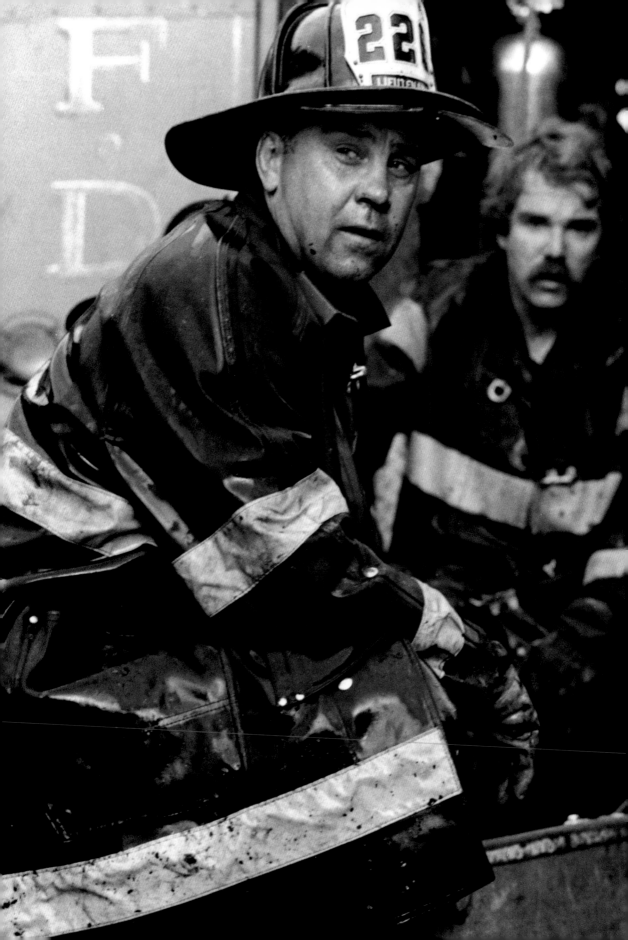

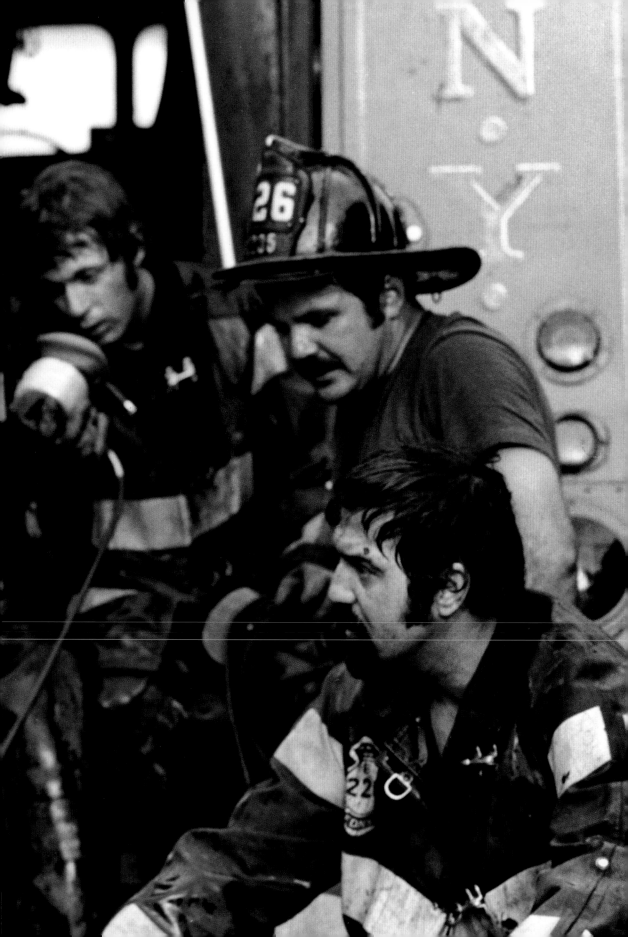

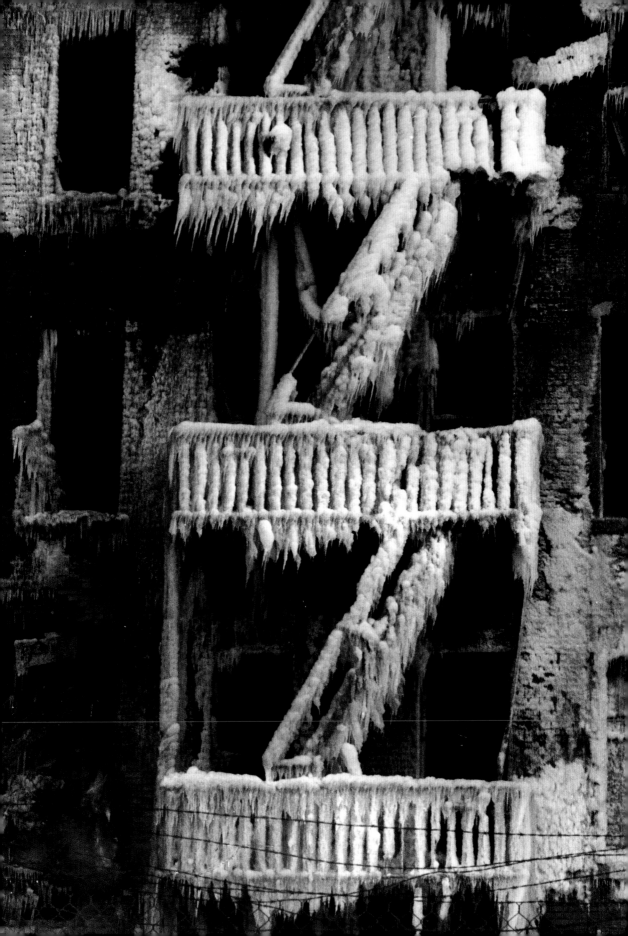

fire marshals were deployed in force, saturating the neighborhoods, and heading off many arson attempts before they happened. Lawmakers also passed legislation making it more difficult for landlords to cash in on burnt-out buildings. A new city council bill stated that landlords could not collect insurance until after they paid their real estate tax (they had been burning

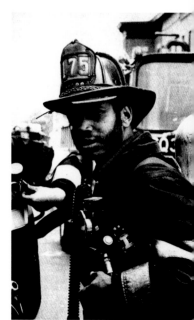

down buildings, collecting the insurance, and then disappearing).

Above Left: *Helping an injured firefighter.*

Above Right: *FDNY firefighter, 1976.*

 The FDNY could finally stop playing catch-up and begin looking ahead. Most firefighters now received the lighter and more efficient Scott Air Pak breathing apparatus, which had been developed by NASA. The old alarm boxes were replaced by the voice-activated Emergency Reporting System, and by the early 1980s fire companies were being dispatched via computer terminals installed in every fire house. In 1980, a leak in a propane tank truck on the George Washington Bridge led to the evacuation of 2,000 people in nearby Manhattan and one of the largest traffic jams in city history. Although an explosion could have caused a fireball one-eighth of a mile wide, two firefighters plugged the leak with a simple plumbing stopper. This near-disaster inspired the formation of the first Hazardous Material Team at Rescue Co. 4. Its members received advanced training and carried specialized equipment to fires and accidents involving chemicals, gases, and other dangerous substances.

Left : *Frozen fire escape after a fire.*
Preceeding pages: *"Taking a blow": members of Engine Co. 226 have a few minutes to rest.*

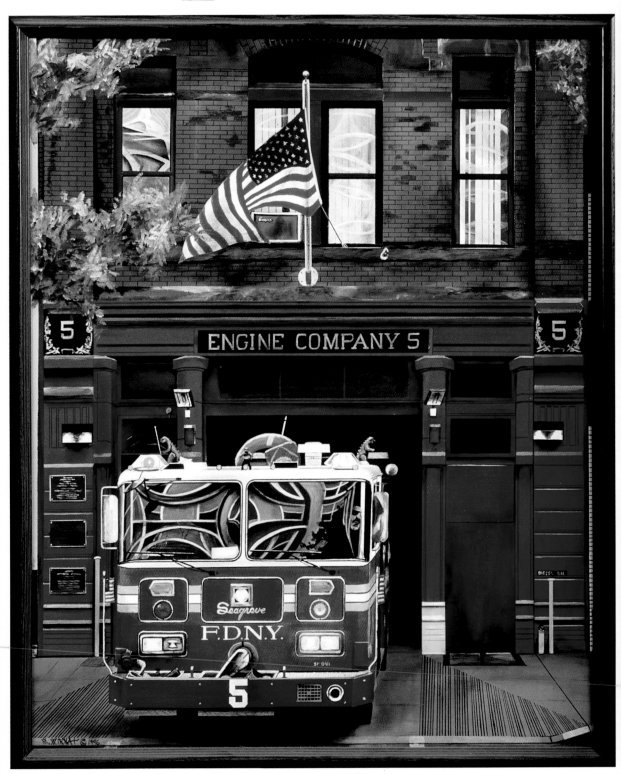

"Hard Left Turn, 14th Street," painting by Marc Winnat, 1997.

MEALS

Assistant Chief Matthew J. Farrell, Manhattan Borough Commander: When I switched over, in 1957, from the police to the Fire Department I found out, much to my shock, that we had to take turns cooking in the firehouse. That's one thing I didn't know anything about. I told my wife, "Gee, I have to cook a meal. What can I make for the fire fighters? They're going to be upset. I can't tell them to skip over the meal. Everyone takes their turn." She said to me, "You can cook spaghetti. All you have to do is take a couple of packages, break it up, put it in hot water, stir it around, and throw it in a colander. You buy a couple of jars of sauce or you make it out of puree." It seemed pretty simple, so I said, "Okay, fine." Well, my turn came up to cook...I was doing fine until we got an alarm for a fire and we jumped on the apparatus and out we went. I forgot to shut off the flame under the spaghetti. When we came back in, I ran into the kitchen. I was horrified to see that the spaghetti had sunk to the bottom of the pot and it had congealed. They were all on the apparatus floor yelling to the kitchen, "When the hell is that meal going to be ready?" So I dumped the spaghetti into the colander, and it all fell out in one large mass. It was the exact shape of the pot. Even the dents at the bottom of the aluminum pot were now in this mass of spaghetti. It was lying in the colander in a big blob and I was staring at it, with all the men yelling into the kitchen, "What are we eating? When are we eating?" Quite frankly I was terrified to tell these guys that there was no meal. We had a large commercial slicing machine that we used to slice cold cuts. I put the spaghetti on like it was a ham, and sliced it. Then I put the slices on the plates and covered them with sauce. After putting the salad and the Italian bread on the table, I called the guys in and just kept my fingers crossed in the hope that I would be able to get by. Well, I should have known better. Fire fighters are a pretty good judge of cooking. One by one they either just looked at is or they tasted it, spit it out, and dumped it in the garbage. Meals didn't cost much in those days; I think dinners were half a dollar a night. The men threw their money on the table. I was so embarrassed I said, "No, it's okay, you don't have to pay." The guys said, "No, it was worth the half a dollar just to find out never to eat with you again."

From "Braving the Flames" by Peter A. Micheels, New York, 1989, 2002

CHANGING CULTURE

*B*y the mid-1970s, a great wave of change was washing through American culture. Women were entering fields reserved for men in unprecedented numbers. To the leaders of the FDNY, it was clear that the arrival of women was inevitable. Given the clannish culture of the department, it was also clear that this change would not be made easily. In 1977, the firefighter test was opened to female applicants for the first time in history. Over 400

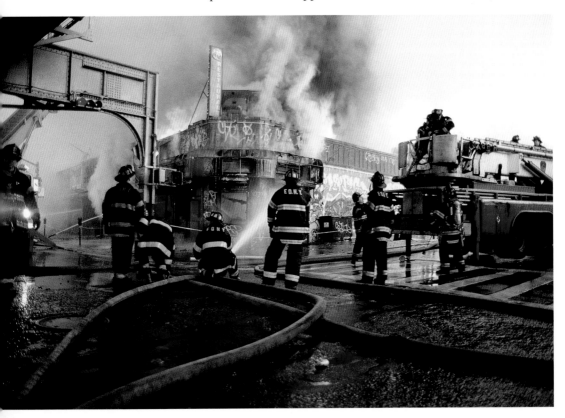

Under the "El": firefighters use a heavy caliber stream to fight a "taxpayer" blaze.

women passed the written test, but next they had to overcome the physical test. It may have been pure chance that this was the toughest physical test ever given by the FDNY. Eighty-nine women took it, and none passed (nearly half the men also failed).

The suspicion arose that the playing field had not been exactly level. In 1981, a failed testee named Brenda Berkman, who happened to be a lawyer, sued the FDNY for a new test. Her argument was

that the test had rated abilities like strength and speed but not skills that were directly job-related. A federal judge agreed with her and, over the protests of the union, a new test was scheduled. Most of the women who took this test were able to drag hoses, hoist ladders, and swing sledgehammers in full firefighter gear in under the allotted time. They were admitted to training school, and those that passed the six-week course at the Randall's Island Fire Academy were assigned to firehouses as probies. By the end of 1982, 34 women wore the uniform of the FDNY, and to the chagrin of many in the department, "fireman" officially became "firefighter."

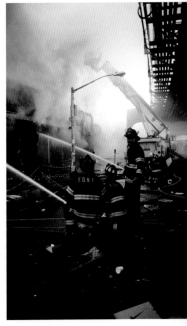

Under the "El": firefighters use a heavy caliber stream to fight a "taxpayer" blaze.

*U*nfortunately, the fight was not over. Most women firefighters faced the same harassment and ostracism that blacks had undergone; a few lucky ones worked under strong captains who forbade this kind of cruelty. Maybe this change would not have been so traumatic if it had happened a decade earlier, when firefighters were working so hard that they did not have time care about the sex or skin color of the person standing next to them, just that they did their job. But now the number of fires was dropping every year, giving some firefighters time to focus on grievances. Women also found little support in either the FDNY leadership or the union. But the women fought back, in the court system and in the firehouse, by doing their job so well that nobody could criticize them. They worked hard and studied hard, and some began to rise to positions of leadership. The department finally began to more closely reflect the changes that were already taking place in society and the private sector workplace.

By the 1980s, the FDNY's aggressive fire prevention and anti-arson programs were showing results. The plague of fires was finally under control, with the help of a gradual improvement in the economy that was giving people jobs. The FDNY finally had time to concentrate on making some technological and organizational improvements. These included buying a new lightweight, hydraulic forced entry device called the Rabbitt Tool and also thermal imaging cameras used for locating hidden fires as well as victims. The Rescue Liaison Unit was established to coordinate emergency

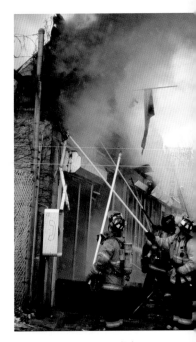

Firefighters use hooks to pull down a sign at a Bronx store fire.

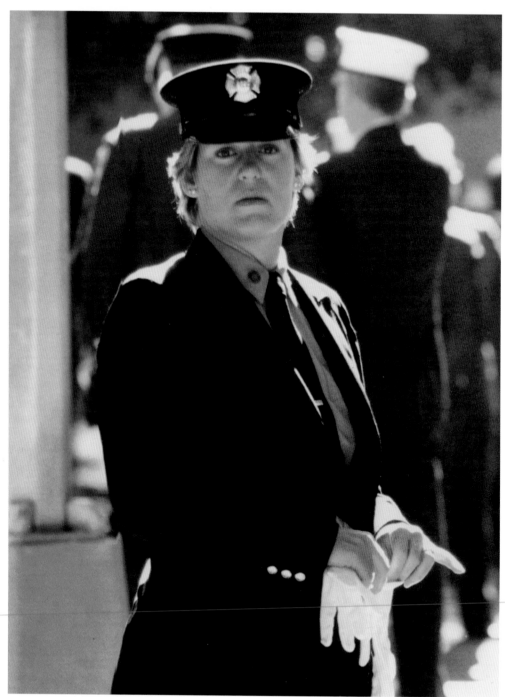

F.F. Eileen Gregan, one of the first woman FDNY firefighters.

WOMEN FIREFIGHTERS

My mother made me become a firefighter. When she heard that the FDNY was opening its entrance test for women, she gave applications to me and my sister. Up to that time, I had never thought about becoming a firefighter, but when I looked at the requirements I said, "Hey, I can do this." I have never regretted it.

From that moment in 1977, it took five long years for me to actually say the firefighters's oath. When the first women took the FDNY exam, most of us passed the written part but none of us passed the physical. One of those who failed, Brenda Berkman, sued on the grounds that the test was not job-related, i.e. did not reflect firefighters' actual work. It took about four years for the case to work its way through the court system, but a judge finally ruled in our favor and ordered that a new physical test must be given. This time, many of us passed, and in September of 1982 the first women entered the Fire Academy on Randall's Island.

It was a hard six weeks. Some of the instructors were great, while others could never accept the fact of women in firefighters' boots. There was no overt harassment, but on the other hand I would say we had it harder than the average men in the program. Nevertheless, 41 of us graduated and were sent to firehouses across the city.

At some houses, the women firefighters were met by picket lines set up by the wives of the firefighters inside. I was one of the luckier ones. I went to Engine 250 in Brooklyn, which had a large number of senior men and was led by a strong captain. He told his men that he expected no nonsense from them, and he told the same to me. We caught a lot of fires my first days there, and this helped me prove that I was capable to pulling my weight. From then on, I had relatively smooth sailing.

It is now 20 years since that first group of women entered the FDNY. On the one hand, we have proved that we can do the job. We have one woman fire marshal, one lieutenant, three captains, and Captain Rochelle Jones is on the list for battalion chief. On the other hand, women still do not find that the Fire Department is the most comfortable place to work. Of that first group of 41 women, only 16 remain (the lawsuit gave us back time to 1980, so many retired after 20 years). Since 1982, only eight more women have joined the ranks, meaning that the department now has only 26 women firefighters. I do not have the answers on how to attract more women to the FDNY but I hope that somebody does. Or else some day we will have to start all over again.

By Firefighter Eileen Gregan

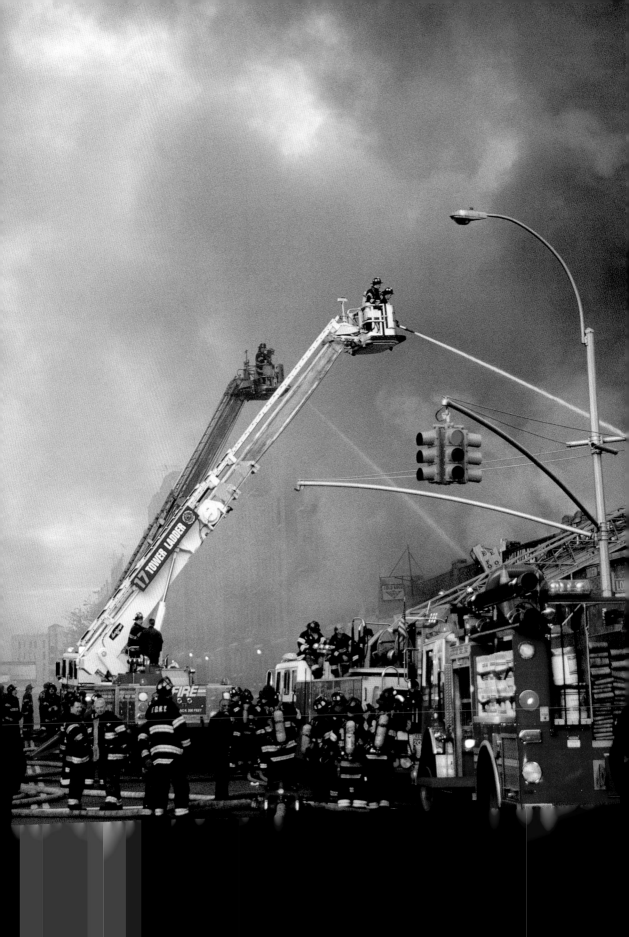

operations with other agencies, while the new Tactical Support Unit brought lighting and other special equipment to fires. Nevertheless, the FDNY could not stop some deadly fires from happening.

*I*n March of 1990, a man named Julio Gonzalez went to a second-floor Bronx social club named the Happy Land to try and win back his girlfriend. Instead, they argued and he left in a rage. Gonzalez then bought a gallon of gasoline and went back to the club. He poured the gas inside the door, threw a match in, and, as the flames began to rise, returned to his apartment to sleep. Only six people inside the Happy Land escaped, ironically including his ex-girlfriend. They managed to survive by leaping through the flames burning in the club's only doorway. By the time the fire engines arrived, 87 people had died from the smoke and flames, most of them immigrants from Honduras. It was the highest death toll since the Triangle fire in 1911. The Happy Land fire exposed chinks in the city's protection against fire, namely lax enforcement and corruption in the building inspection program. Bureaucrats were fired and policies changed, but this could not bring back the 87 dead.

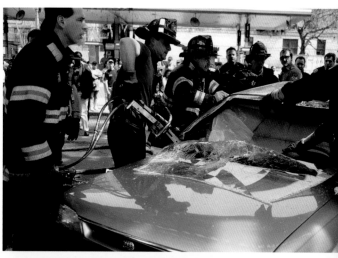

Firefighters use the "Jaws of Life" to rescue a car accident victim.

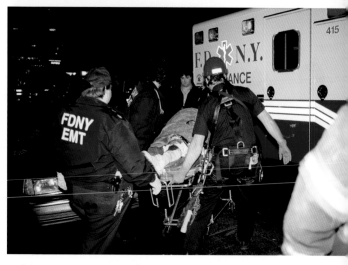

FDNY EMTs rush a victim from a blaze.

Fires of the Happy Land type were nothing new in New York City history; it was only the horrendous scale of loss that made it unusual. Three years later, however, the FDNY faced a challenge that was altogether different from anything it had seen in the past. On February 26, 1993, a rented van parked in a basement garage underneath the World Trade Center's north tower exploded.

Left page: Tower ladders at work in the Bronx.

THE EMERGENCY MEDICAL SERVICE

In 1869, New York City's first ambulances rolled forth from Bellevue Hospital. Carrying doctors, these horse-drawn wagons brought medical care to accident victims and the sick in the city slums. The rich and middle class preferred to convalesce at home, no matter how dire the case-hospitals did not use antisepsis back then and were rightly considered more dangerous than a well-cleaned home. As the city's population boomed, ambulance calls quickly increased, and it became part of all doctors' training to ride in the wagons during their interning years. Luckily, medical care was making great strides during this era, and by the early 1900s hospitals were becoming places in which even the rich wanted to be sick.

From 1909 on, the city's hospital-based ambulances operated under the supervision of the Board of Ambulance Service (later the Division of Ambulance Service of the Department of Hospitals). Their level of service, however, was highly variable. Although the first motorized ambulance went to work in 1908, it was another 15 years before the last horse-drawn wagon was withdrawn from service. All ambulances carried

patients only to their own hospitals, regardless of distance and treatment needed, and whole areas of the city were left without coverage.

Numerous city administrations noted the problems with ambulance service, but real change did not begin until the term of Mayor John Lindsay. In 1968, control of all city municipal ambulances was centralized under the Ambulance and Transportation Division of the Department of Hospitals. Two years later the latter became the Health and Hospitals Corporation (HHC), and the ambulance division was renamed the Emergency Medical Service (EMS). The next challenge was to standardize ambulance service across the city.

First, all ambulance attendants were required to become New York State Certified Emergency Medical Technicians (NYS EMT). Then the ambulance drivers, who up to this time had never given patient care, were also asked to begin training as EMTs. In 1974, a program at the Albert Einstein College of Medicine began teaching EMTs (and a small group of drivers) to be certified paramedics, giving

them a much higher level of emergency medical training. These paramedics soon proved that many more lives could be saved if people were given advanced treatment at the scene rather than waiting until they reached the emergency room. From then on, specialized training became-and remains-a top priority of the EMS.

With the reorganization of the ambulance service also came a long overdue centralization of the dispatch system. The newly-opened EMS Communications Center was tied in to the new 911 system; now ambulance calls were routed to a trained EMS operator who could not only take down details of the call but give medical care instructions over the phone. Next, the call was given to an EMS dispatcher who routed the ambulance to the place where help was needed. Since then, there have been numerous improvements to the EMS's communications system, each leading to life-saving reductions in response time.

On March 17, 1996, the Emergency Medical Service was consolidated into the New York City Fire Department. One of the major initiatives of Mayor Giuliani, this change was motivated by a number of factors. The HHC was undergoing financial problems at the time, so the move into the

FDNY would produce savings by combining services. The merger was also part of a nationwide trend for fire departments to take over municipal ambulance services. Due to its firehouses in nearly every neighborhood, the FDNY could reach any address in the city within three-and-a-half minutes, while ambulances took on average eight minutes. As the Fire Department was already providing back-up to many medical calls, it made sense to combine the operations.

Since the merger, the Emergency Medical Service has become an integral part of the FDNY. The over 2,600 EMTs and paramedics of the FDNY/EMS are trained in both basic and advanced life support and respond to more than a million medical emergencies a year. At the same time, all firefighters and officers assigned to engine companies are given Certified First Responder-Defribillator training, allowing them to treat certain life-threatening conditions at the scene. These three tiers of service, CFRD and basic and advanced life support, now give the FDNY/EMS a seamless pre-hospital emergency medical system. From its primitive beginnings over a century ago, New York City's ambulance system is now recognized as the largest and most sophisticated in the world.

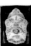

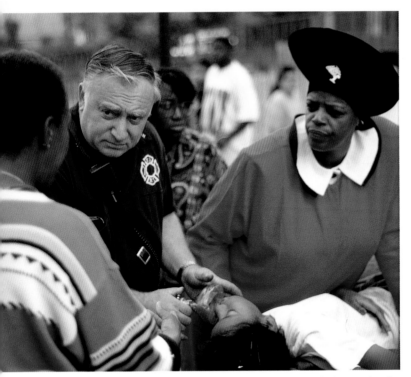

A lieutenant at Engine Co. 10 on nearby Liberty Street heard a thud and saw the World Trade Center's lights flicker. A transformer explosion, he thought, and he called for back-up just in case. Upstairs, office desks shook. As people began to wonder what had happened, smoke began to filter up the stairways and elevator shafts. Then most of the lights went out and the elevators stalled. When the first firefighters walked down the ramp of the World Trade Center garage and saw through the smoke the terrible devastation, they knew that it had not been a transformer explosion.

Giving a victim oxygen as relatives look on.

*M*iraculously, the fires were put out within a couple of hours, and the World Trade Center's supports remained essentially sound. The main work of the 750 firefighters who arrived at the scene was rescue. Approximately 50,000 office workers and tourists were brought to safety that afternoon in the largest rescue operation in American history. This included an incredible operation to retrieve injured firefighter Kevin Shea, who had tumbled into the huge pit caused by the blast. Only six people died, most of them Port Authority employees working in the sub-basement. It was left to the NYPD and the FBI to discover who was behind this attack: Islamic terrorists angry at the United States's role in the Middle East. For them, the World Trade Center symbolized Wall Street, New York City, and the United States— everything they hated. They hoped that if they destroyed it, they could force the United States to stop supporting Israel and meddling in Arab affairs.

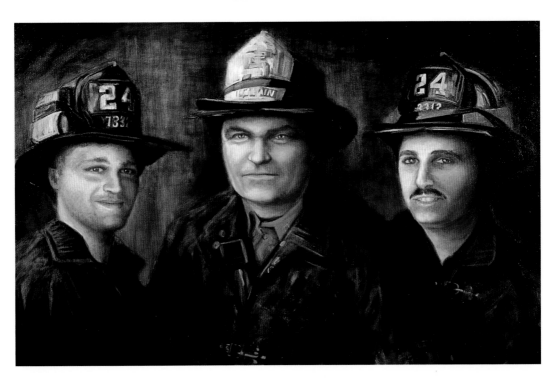

There were lessons to be learned from the 1993 World Trade Center attack. Emergency planners discovered that the FDNY's radios did not work in massive structures like the World Trade Center; they called for "repeaters" to be installed in the complex that would strengthen the radio signal. They also suggested that the FDNY and the NYPD learn to communicate better in order to coordinate efforts at disasters. New Yorkers learned that their beloved city was not secure from terrorist attack. Fighting battles occurring halfway around the world, these terrorists would target New York's most important landmarks and try to cause the maximum amount of casualties. And once again, the issue of building codes came up. The FDNY told politicians that the codes for high-rise structures were inadequate for protecting lives in large-scale disasters. All these questions were debated, and some solutions put in place, but by and large complacency set in. People decided not to take action, because nobody believed it would happen again.

"Watts Street Fire Heroes, 1994," painting by Michael Molly. Three firefighters who made the ultimate sacrifice, from left: FF. Christopher J. Seidenberg, Capt. John J. Drennan, and FF. James F. Young.

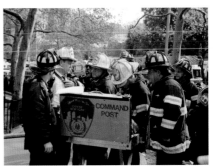

The command post helps officers keep track of all units at a fire scene.

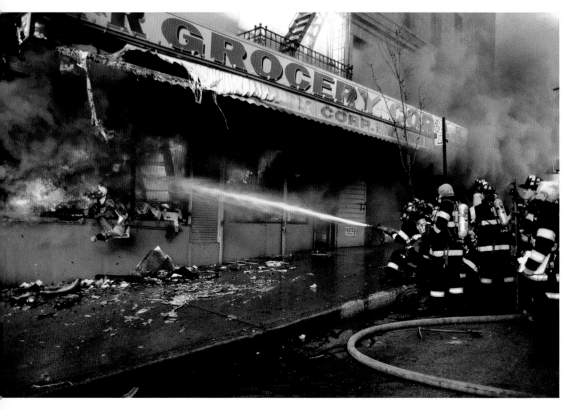

A "taxpayer" blaze: firefighters take a defensive position.

Firefighter Teresa French manning the command board at an all-hands fire in Williamsburg, Brooklyn.

*M*eanwhile, the number of fires was declining to levels not seen since the early 1960s. The city was undergoing another fiscal crisis, and Mayor Giuliani needed to streamline operations as much as possible. Many firefighters had already received emergency medical training and were often the first to respond to 911 calls for medical help. Now that firefighters supposedly had so much downtime, Giuliani decided to expand the emergency medical part of the FDNY job description. In 1996, he merged the FDNY with the Emergency Medical Service, not without some grumbling in the fire department. All firefighters assigned to engine companies are now given Certified First Responder-Defibrillator training. They now make up the first line in the city's emergency medical response, usually reaching ill or injured people first and giving treatment until the EMTs arrive and take over.

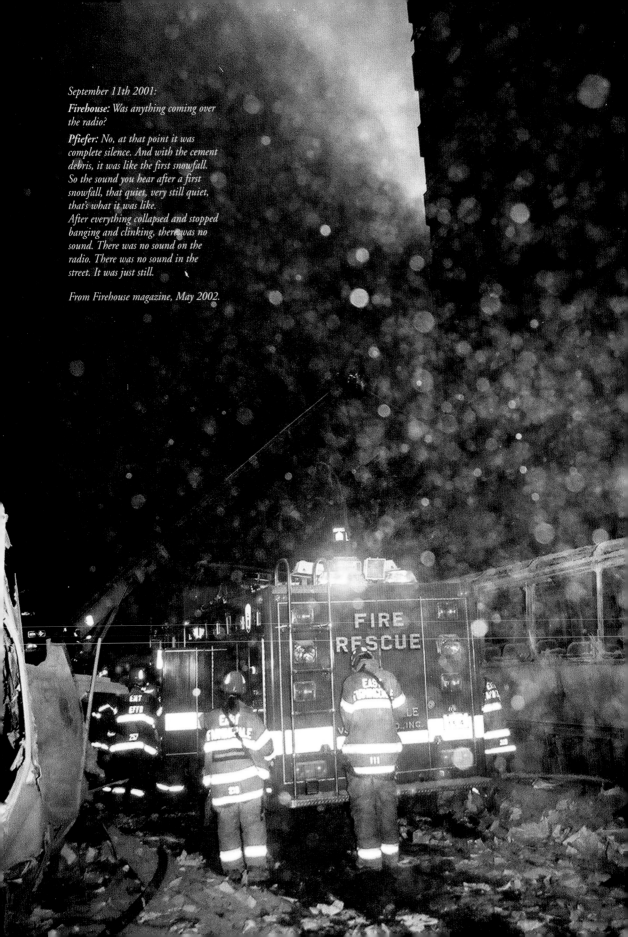

September 11th 2001:

Firehouse: *Was anything coming over the radio?*

Pfiefer: *No, at that point it was complete silence. And with the cement debris, it was like the first snowfall. So the sound you hear after a first snowfall, that quiet, very still quiet, that's what it was like.*
After everything collapsed and stopped banging and clinking, there was no sound. There was no sound on the radio. There was no sound in the street. It was just still.

From Firehouse magazine, May 2002.

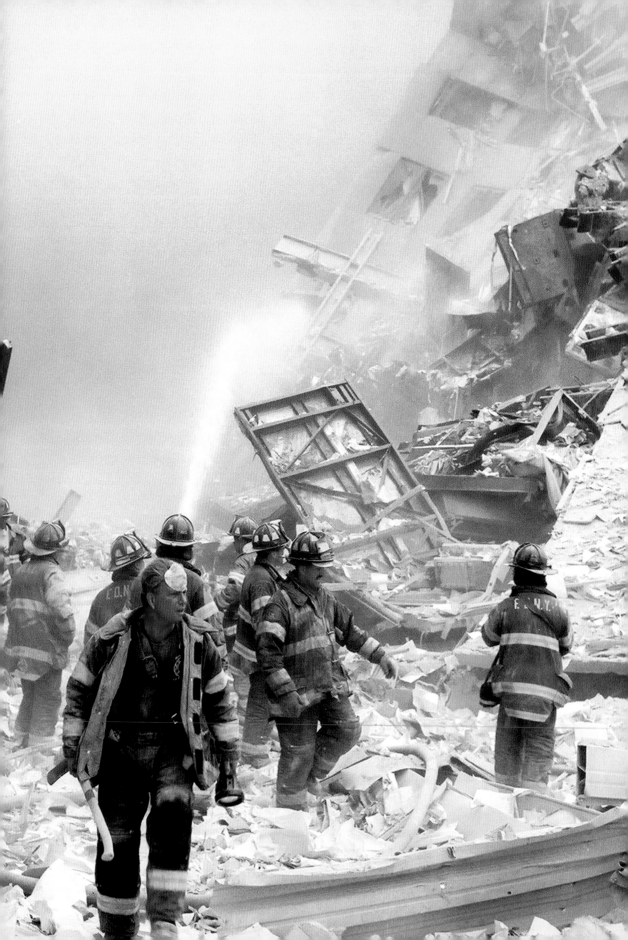

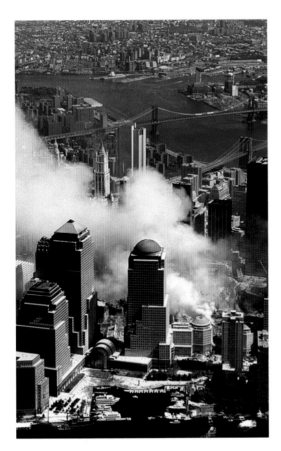

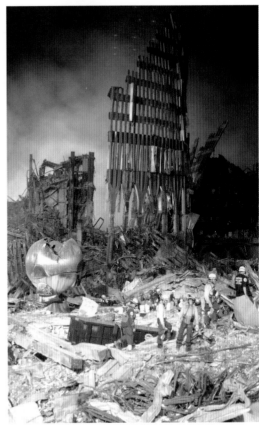

"THE WORST DAY OF OUR LIVES"

On Tuesday, September 11, 2001 at 8:47 a.m. the first of two passenger jets hijacked by terrorists was deliberately flown in to the 110-story World Trade Center Tower One. Eighteen minutes later the second jet struck the upper floors of Tower Two. These two attacks-of four around the nation that day-became the deadliest terrorist attacks ever on U.S. soil.

Chief of Department Peter Ganci witnessed the aftermath of the first jet to attack the towers from his office window at FDNY Headquarters in Brooklyn. Ganci responded with the Chief of Operations Daniel Nigro. While still enroute, Ganci requested two more alarms to respond to 1 World Trade Center. Smoke and fire were visible from ten floors. Ganci told Nigro, "This is going to be the worst day of our lives".

Top Left: *Aerial view of Lower Manhattan, September 11th, 2001.*

Top Right: *Ground Zero, September 12th, 2001.*

Left: *Recovery crews working round the clock beneath the shattered remains of the World Trade Center.*

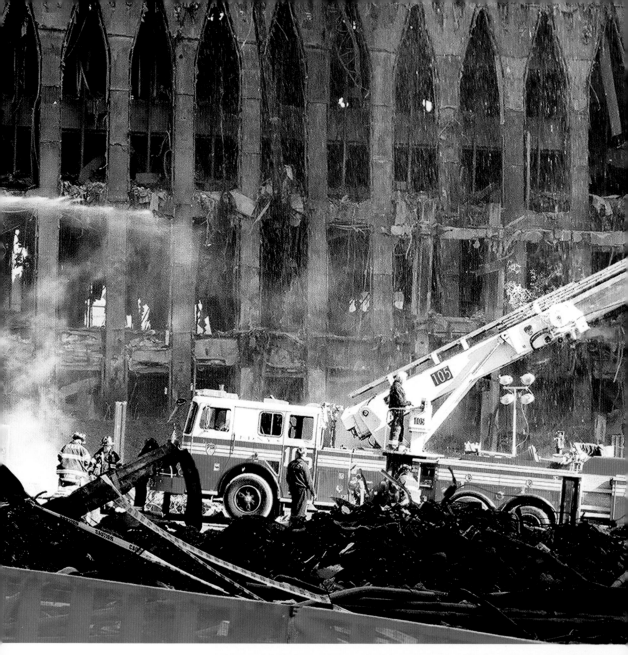

Above: *Ladder Co. 105 hosing down the smoldering rubble.*

The truck is a replacement, rushed into service after the original was destroyed on September 11th.

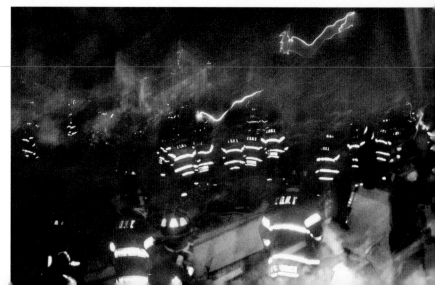

Right: *Firefighters search the smoldering rubble on the night after the attacks.*

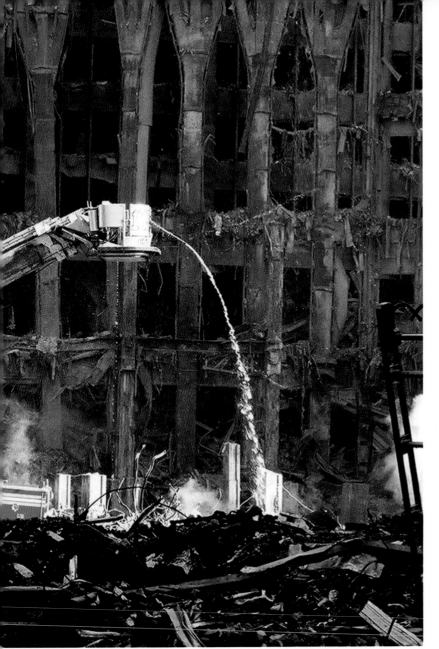

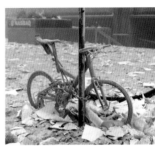

Dust-covered bicycle on September 11th, 2001.

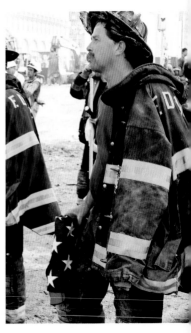

Above: *Most firefighters working at Ground Zero carried flags which they used to drape the remains of recovered brothers.*

Left: *September 14th , 2001: President Bush meets Ground Zero workers, with FDNY Chief of Department Daniel Nigro on his right.*

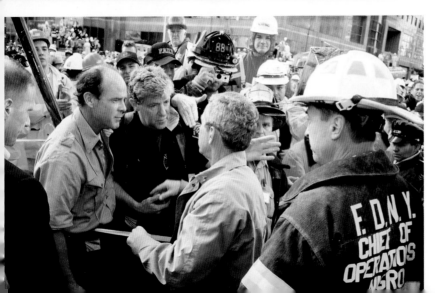

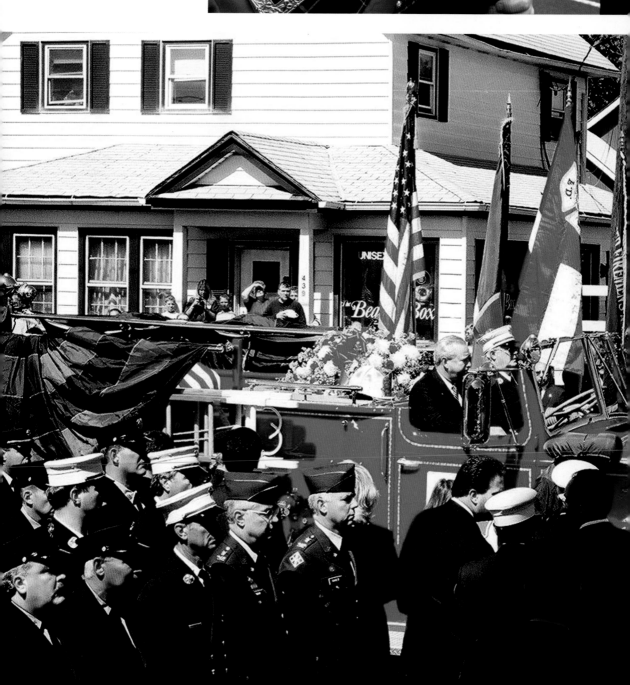

FDNY Emerald Society bagpipers in the St. Patrick's Day parade, 2002.

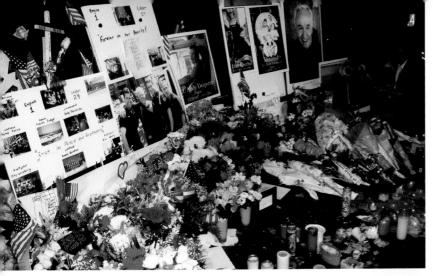

Memorial to fallen firefighters. A photo of Father Mychal Judge is on the right.

"Lord, take me where you want me to go. Let me meet who you want me to meet. Tell me what you want me to say and keep me out of your way."

Written by Father Mychal Judge, the FDNY's Chaplain, who made the supreme sacrifice on September 11th, 2001.

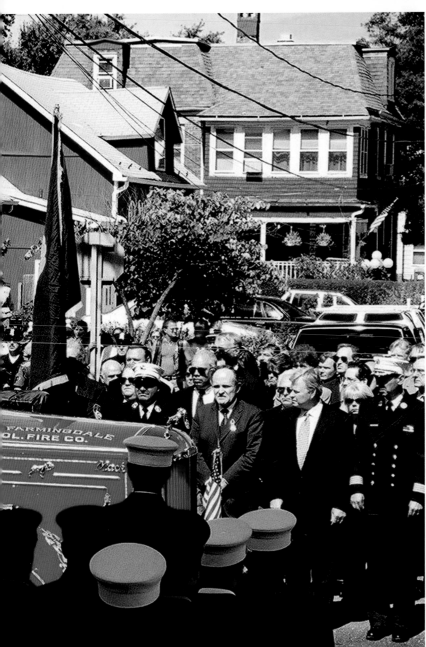

Peter Ganci's son at his father's memorial service.

Left: September 15th, 2001: The funeral of Chief of Department Peter Ganci in Farmingdale, Long Island.

Mayor Giuliani and Fire Commissioner Von Essen are on the right.

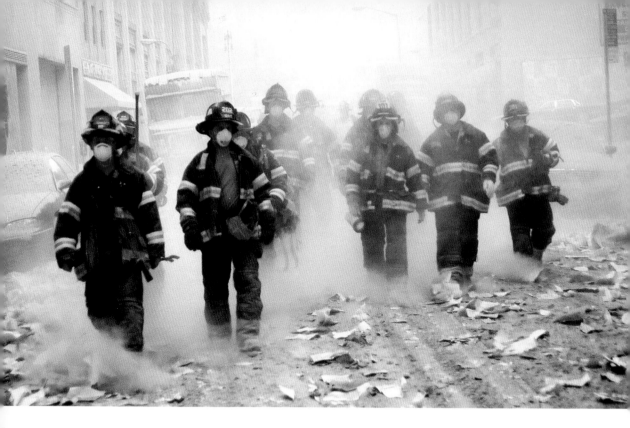

Rescue crews on September 11th, 2001.

*W*ithin an hour or two between 20 and 25 alarm assignments of companies were operating on the scene. The department quickly issued a total recall of off-duty members, its first in over 50 years. Firefighters helped rescue and remove over 25,000 civilians who worked in or were visiting the seven-building complex spread over 16 acres in lower Manhattan. Fifty-six minutes after being struck, Tower Two suddenly collapsed. Thirty minutes later Tower One collapsed as well. Numerous buildings nearby were damaged or destroyed by falling tons of steel. Nearly 90 pieces of fire apparatus, including engines, ladders, special rescue units, EMS units and passenger/command vehicles, were destroyed. Initially it was presumed that over 400 firefighters were killed or missing, along with unknown thousands of civilians.

Lower Manhattan was covered in smoke and dust. Fires burning under the collapsed debris thwarted rescuers who were searching for bodies and any who might have miraculously lived through the collapse. Only a few survivors were found. The smoldering fires burned on for months. Despite making an unprecedented number of rescues, the department paid a terrible price. The FDNY suffered the worst one-day death toll in its 136-year history: 343 firefighters,

officers and chiefs died in the attack. That was the worst line-of-duty toll in the 350-year history of American fire fighting.

The trauma continued over the days and weeks and months that followed. In what became the largest rescue, then recovery, operation ever attempted, FDNY units remained at the disaster scene until early June of 2002, searching for firefighters and civilians in the millions of tons of debris excavated from the scene. The wail of bagpipes and the roll of drums was heard on Fifth Avenue and Staten Island; in Queens, Brooklyn, and the Bronx; and all across Long Island and the other suburbs. Firefighter's funerals were a daily event. Amid this staggering tragedy came the long overdue recognition of the bravery and selflessness of New York's firefighters. For the city and also the nation, the men and women who wore the FDNY uniform became the ultimate symbol of heroism.

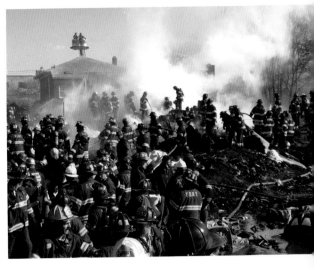

November 12, 2001: Firefighters at the Flight 587 crash in Belle Harbor, Queens.

December 2001: Tower ladders at the Cathedral of St. John the Divine fire.

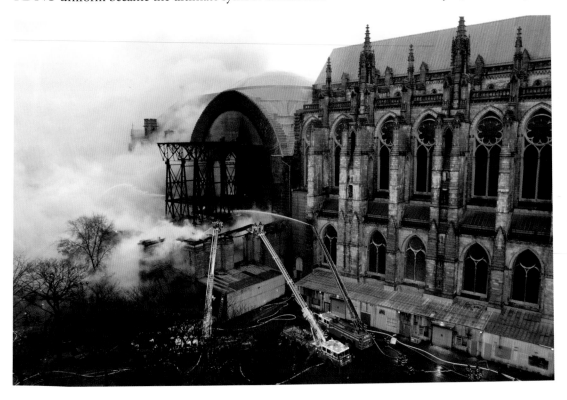

A Brief Timeline

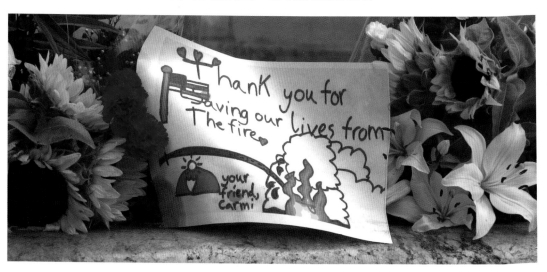

1613 – Fire leads to first European settlement on Manhattan

1625 – Dutch West India Company establishes permanent settlement

1648 – First fire regulations in New Amsterdam

1658 – First organized fire company, called the Rattle-Watch

1664 – Britain takes over the colony, renames it New York

1731 – First hand-pumped fire engines ordered from London

1737 – Volunteer fire department established

1776 – September 21, fire destroys much of city after its capture by British troops

1783 – British troops defeated

1785 – Brooklyn's volunteer fire department established

1798 – Fire Department of the City of New York incorporated

1807 – First fire plug attached to a water main

1808 – Crude fire hoses introduced

1835 – December 16, fire destroys most of city's business district, with huge losses

1842 – Croton Aqueduct opens, ensuring city's water supply

1847 – City divided into fire districts

1850 – City population 515,000

1851 – First telegraph fire alarm

1854 – Insurance companies establish paid Fire Patrol

1858 – October 5, Crystal Palace fire

1859 – First steam-powered fire engines in service

1863 – July 13-17, Draft Riots sparked by firemen almost destroy city

1865 – July 13, Barnum's Museum burns for the first time

1865 – Paid Metropolitan Department replaces volunteer force

1870 – First street alarm boxes installed

1875 – First true fire boat launched

1876 – December 5, Brooklyn theater fire, 296 die

1898 – Greater city of New York formed; FDNY's area expands greatly

1903 – Work begins on high-pressure hydrant system

1910 – City population 4.8 million

1911 – March 25, Triangle Shirt Waist fire

1912 – Fire Prevention Bureau established

1919 – First firefighter's labor union

1920 – September 16, Wall Street explosion

1922 – Last run by a horse-drawn fire engine

1935 – April 20, Furman Street fire on Brooklyn waterfront

1942 – February 9, *Normandie* fire

1945 – July 28, bomber hits Empire State Building

1956 – December 3, Brooklyn pier explosion

1960 – December 16, airplane crashes in Park Slope, Brooklyn

1960 – December 19, fire aboard aircraft carrier *U.S.S. Constellation*, 50 killed

1965 – Superpumper enters service

1966 – October 17, Manhattan loft fire, 12 firefighters die

1975 – Fire runs hit annual peak of 398,867

1982 – First women firefighters

1990 – NYC population 7.3 million

1990 – March 25, Happy Land Social Club fire, 87 die

1996 – Emergency Medical Service becomes part of FDNY

2001 – September 11, World Trade Center destroyed by terrorists, worst day in FDNY history

2001 – November 13, American Airline crash in Queens

2002 – May 30, closing of Grand Zero site

2002 – October 12, Memorial Service for 9/11

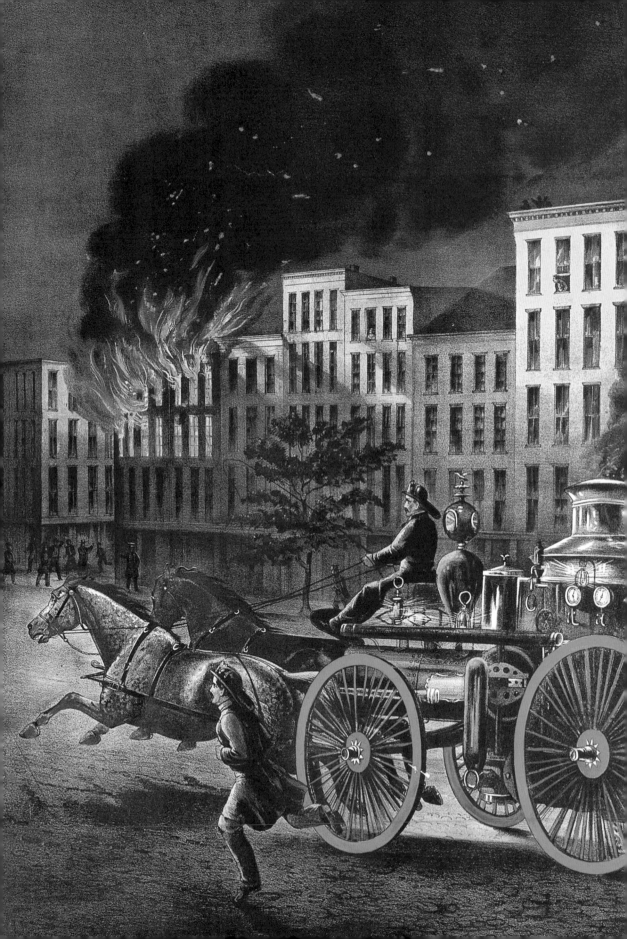